IMAGES
of America

HILLSBOROUGH

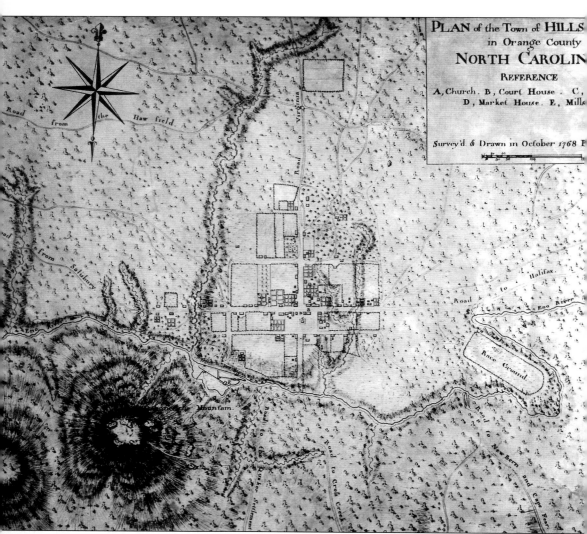

Swiss surveyor Claude Joseph Sauthier completed this detailed and exact map of Hillsborough in 1768 for Gov. William Tryon. (Courtesy of Orange County Historical Museum.)

(*on the cover*) An unidentified group of *c.* 1900 picnickers are pictured at the overlook on Occoneechee Mountain. (Courtesy of Hillsborough Historical Society.)

IMAGES
of America

HILLSBOROUGH

Chris Holaday

ARCADIA

This book is dedicated to the people of Hillsborough and the surrounding area, who are the reason the town has been such a special place for nearly 250 years.

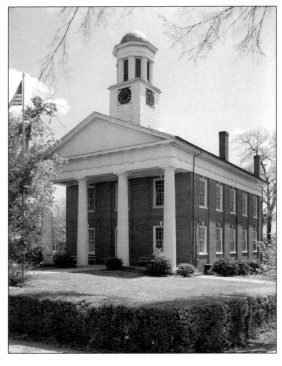

Hillsborough's most familiar building is, without a doubt, the old Orange County Courthouse. Seen here in a 1960s photo, the building was constructed in the Greek Revival style by famous local builder Capt. John Berry on the site of an earlier courthouse. (Courtesy Library of Congress.)

CONTENTS

ACKNOWLEDGMENTS

It is difficult to capture the rich history of a town such as Hillsborough in a book of only 200 photographs. Fortunately, I had much help gathering the images in this book that I hope are representative of Hillsborough's homes, people, and heritage.

Immensely helpful in this project were Ernest Dollar at the Orange County Historical Museum, Keith Longiotti at the University of North Carolina, and Brooks Graebner and Cheryl Junk of the Hillsborough Historical Society. I could not have completed this book without their enthusiastic assistance.

I would also like to thank the Hillsborough residents who opened their photo albums and shared their memories and knowledge. Many thanks go to Mandy Tabor, Chandler Cates, Bill Crowther, Donna Freeland, Brendan Moylan, Kathleen Wagner, Margaret Whitted, Marsha Stanley, Jeff Cabe, Melissa Stanley, Truitt Stanley, Kathy Darst, Shelly McGraw, and Lucius Cheshire. Though I never met her, I would also like to acknowledge Lucille Noell Dula, whose *Pelican Guide to Hillsborough* provided much information about the town's historic homes.

Special thanks go to Bitsy McKee for her skill and time and to my wife Sue for her help and unwavering support.

INTRODUCTION

No one knows when the land upon which Hillsborough sits was first home to human inhabitants. In June of 1670, German physician and explorer John Lederer may have been the first European to visit the area. His travels, sponsored by the governor of Virginia, documented thriving villages of the Shakori Indians in the area. It would then be 31 years before another European returned to the place now called Hillsborough. In 1701, English surveyor John Lawson visited a village of the Occaneechi Indians along the banks of the Eno River. Though he didn't stay long (Lawson did later establish North Carolina's first town, Bath, in 1705), he published an account of the area's native population in his book, *History of Carolina*.

The Occaneechi eventually abandoned the area, but it wasn't long before the thick forests and rich soil of the region began to attract English colonists living in Virginia and eastern North Carolina. In 1754, on a 400-acre tract where the Great Indian Trading Path crossed the Eno River, surveyor William Churton laid out the town that would become Hillsborough. In early years, the colonial outpost went through several names—Orange, Corbinton, and Childsburg—before settling upon Hillsborough in 1766. The town name was eventually shortened to Hillsboro.

Hillsborough, designated as the county seat of Orange County, soon became an important center of colonial commerce. Because of this, the town was at the heart of the Regulator movement, which was organized in the late 1760s to protest corruption in the local colonial government (Hillsborough loyalist leader Edmund Fanning was the focus of much Regulator animosity). The movement was finally put down in May of 1771 when Governor Tryon and the militia defeated the Regulators in a battle at Alamance. The following month six captured Regulator leaders were hanged at Hillsborough.

Several years later, when the Revolutionary War erupted, Hillsborough continued to play a key role in events. Skirmishes between loyalist Tories and rebel Whigs were fought around the area and British general Lord Cornwallis occupied the town for a week in 1781. Reportedly, he found Churton Street to be such a muddy mess that he ordered his soldiers to pave part of the street with flagstones (much like those in front of the Colonial Inn today).

Hillsborough was at the height of its influence and importance in the last two decades of the 1700s. After the war, the new state chose Hillsborough as the site of its Constitutional Convention in 1788. In what would prove to be a significant event for the entire United States, delegates at Hillsborough voted against ratification and recommended that amendments be added to guarantee the rights of citizens. (The following year, after a Bill of Rights was

proposed, North Carolina did vote to ratify the Constitution in Fayetteville.) There was even an attempt to have Hillsborough made the capital of North Carolina, but in 1792, the General Assembly made the new town of Raleigh the permanent seat of government.

By the mid-1800s, Hillsborough had lost the prominence it had in its early years and had essentially become a sleepy little rural town. By the end of that century, however, industrialization finally reached the area and the town was reborn. As with so many towns across North Carolina, the textile industry brought a boom to the economy. Construction of the Eno Cotton Mill began in 1896 on the banks of the Eno River on the western edge of town. It brought jobs and spurred town growth as people gave up the uncertainties of farm life for steady work in the mill. Tobacco also played a prominent role in Hillsborough's economy during the late 1800s, though that industry would soon be overshadowed by the giant companies of neighboring Durham.

In the 1960s, Hillsborough residents began to rediscover the rich history of their town. One of the leaders of this new historical preservation movement was Mary Claire Engstrom, who lived in the historic Nash-Hooper house. Engstrom, the wife of a University of North Carolina (UNC) professor and a Ph.D. of English literature herself, spent years researching the history of Hillsborough and documenting its historic buildings. She wrote numerous articles on local history, helped many buildings qualify for a spot in the National Register of Historic Places, and in 1963, she founded the Hillsborough Historical Society.

It was during this time of renewed appreciation for the town's history that it was discovered that its name had never been officially changed to Hillsboro. So, in reverence for the town's history, the official name Hillsborough was re-adopted beginning in the mid-1960s.

In recent years, Hillsborough has once again flourished. Due to its location between two large urban regions, the Triad (Greensboro, Winston-Salem, and High Point) to the west and Durham, Raleigh, and the Research Triangle to the east, the town has become a popular and convenient place to call home. Though today Hillsborough deals with modern issues such as traffic and booming sub-divisions, it has done so without breaking its link to the past or losing its small-town charm.

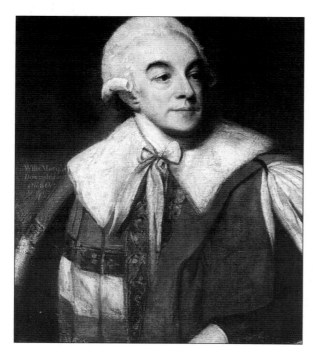

The town of Hillsborough was named for Wills Hill (1718–1793), the Earl of Hillsborough. Later given the title Marquess of Downshire, Hill was president of England's Board of Trade and Plantations for several years and from 1768 to 1772 he served as secretary of state for the colonies. (Courtesy of Hillsborough Historical Society.)

One

HILLSBOROUGH HOMES

The Nash-Hooper House on West Tryon Street, perhaps the town's most important private home, has had several famous owners. The home was built in 1772 by Gen. Francis Nash, who died at the Battle of Germantown during the Revolutionary War. In 1781, William Hooper, signer of the Declaration of Independence, purchased the house and his family owned it until the 1850s. After the Civil War, Gov. William A. Graham lived in the house. (Courtesy Library of Congress.)

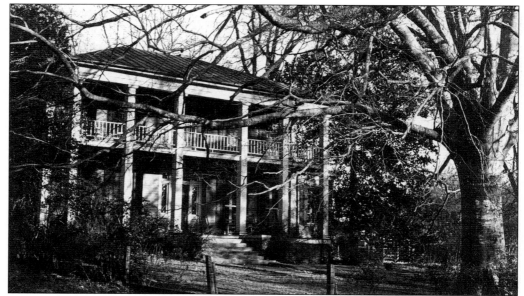

Tamarind, on North Churton Street, was built in 1903 by Shepperd Strudwick on the site of the *c*. 1831 William Bingham house (which was moved down Union Street). The architect of Tamarind was Ralph Adams Cram, Mrs. Strudwick's brother-in-law. One of the nation's most prominent architects of Gothic structures, Cram designed numerous churches including the Cathedral of St. John the Divine in New York. He is also responsible for buildings on many college campuses including Princeton, Rice, MIT, and the University of Richmond, among others. (Courtesy of Hillsborough Historical Society.)

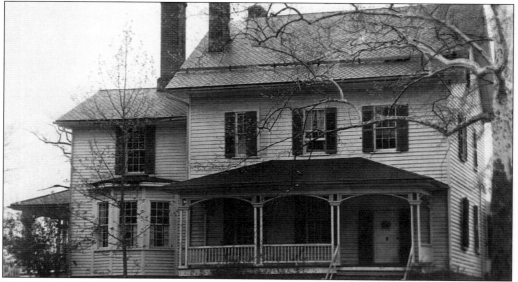

Burnside is one of Hillsborough's most impressive homes. Located at the eastern end of Margaret Lane across Cameron Street, the earliest portion of the home was constructed in 1833 by Paul Cameron. Enlarged several times over the years, it features many striking architectural details. The grounds of the estate, sometimes called Cameron Park, are equally imposing. (Courtesy of Hillsborough Historical Society.)

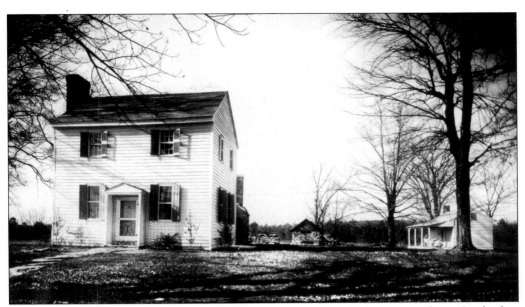

The Dickson House is seen here on its original site in a mid–20th-century photo. In the last days of the Civil War, the army of Confederate general Wade Hampton camped in the fields around the house and Hampton used the outbuilding (seen at right) as his office. It was here that Gen. Joseph Johnston came to meet with other Confederate leaders about the possible surrender of his army. Johnston then rode a few miles east to the farm of James Bennett to meet Sherman for surrender discussions on April 17 and 18, 1865. (Courtesy of North Carolina Collection, University of North Carolina Library at Chapel Hill.)

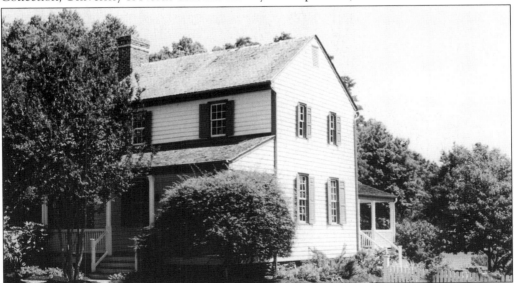

The late-1700s Alexander Dickson House was originally located at the intersection of I-85 and Highway 86, a little over a mile from where it currently sits. Now located next to the Hillsborough Post Office on the southwest corner of East King Street and Cameron Street, the house was moved in the early 1980s and restored to become the town's visitors center. (Photo by the author.)

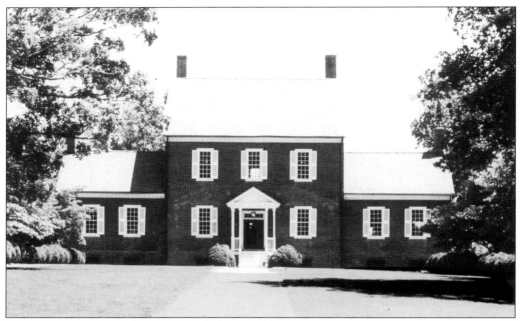

Ayr Mount is perhaps the most stately historic house in the Hillsborough area. Merchant and planter William Kirkland constructed the grand brick home around 1815 on his 500-acre plantation located east of downtown on the Halifax Road (now St. Mary's Road). In the 1980s, it was purchased by financier Richard Jenrette. He restored it to its original appearance, furnished it with period pieces, and donated it to the Classic American Homes Preservation Trust. The house and surrounding land are now open to the public. (Photo by the author.)

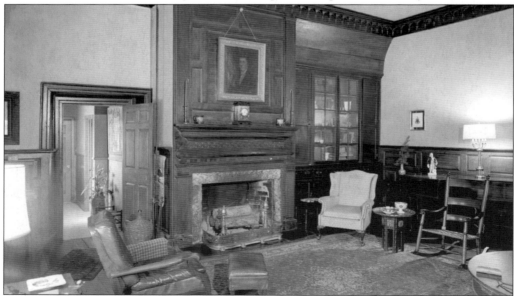

The interior of Ayr Mount, seen here in a 1960s photo, features high ceilings, elaborate moldings and cornices, and fine overmantels. The woodwork in the house was reportedly milled from trees felled on the site and the bricks were fired from clay found on the plantation. (Courtesy Library of Congress.)

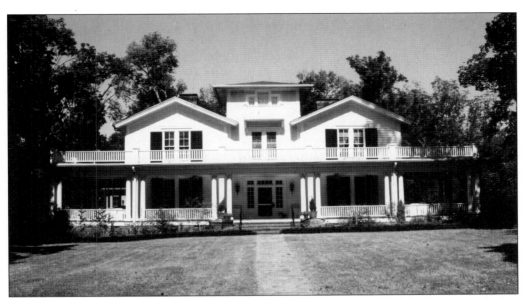

Bellevue, located at the intersection of St. Mary's Road and East Tryon Street, has been remodeled several times over the years but the oldest portion dates to the end of the 18th century. It was converted to an Italianate style structure in the 1850s and the expansive porch was added around 1920. The historically important kitchen adjacent to the house is one of the oldest brick structures in town. Today, the house serves as a bed and breakfast, the Hillsborough House Inn. (Courtesy of Hillsborough Chamber of Commerce.)

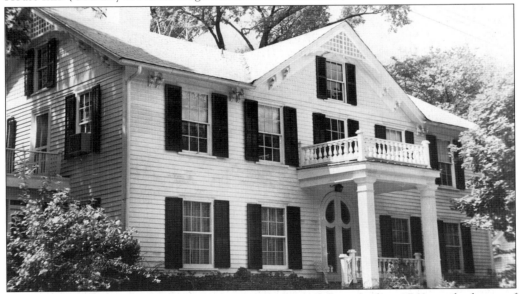

The Parks-Richmond House on West King Street began life in the late 1760s as the home of innkeeper Thomas King and his wife Sophia. In the 1880s, the house was enlarged and its appearance altered by remodeling. It eventually became part of the Occoneechee Hotel (Colonial Inn), which stands next door, when the entire complex was operated by D.C. Parks. Today, the house is a bed and breakfast, the Inn at Teardrops. (Courtesy of Hillsborough Historical Society.)

The Ruffin-Roulhac house on the northwest corner Churton and East Corbin Streets was once part of the 10-acre estate of Francis Lister Hawks. The earliest portion of the house was built in the 1820s with additions constructed in the 1830s. From 1865 until his death in 1870, it was home to Chief Justice Thomas Ruffin. The house was later restored to serve as Hillsborough's town hall. (Courtesy of Hillsborough Historical Society.)

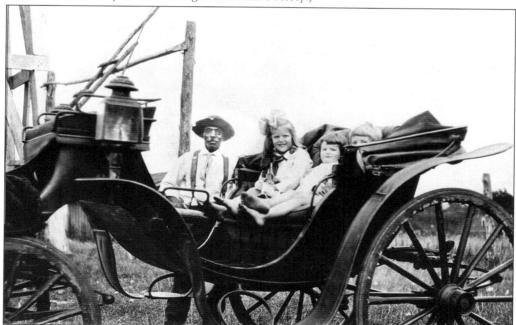

Price Jones, coachman for the Roulhac family, poses with the family's children in front of the Ruffin-Roulhac house in the late 1800s. Part of the supporting structure for the home's water tower can be seen at far left. (Courtesy of Hillsborough Historical Society.)

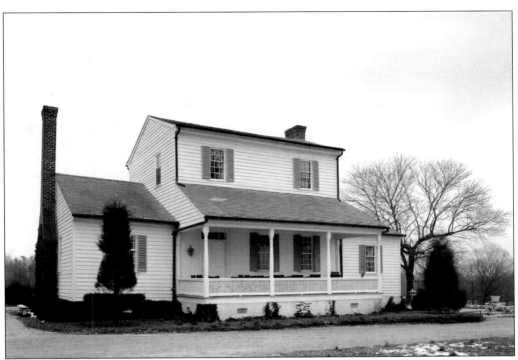

The two photos on this page show front and back views of Moorefields, which was built in 1785 by Alfred Moore on his 1,202-acre estate. A distinguished citizen of the day, Moore served as chief justice of the North Carolina Supreme Court and in 1798 he was appointed to the United States Supreme Court. In 1949, the house was purchased by UNC professor and sculptor Edward Draper-Savage. He restored it and upon his death in 1978, Moorefields was left in the care of a foundation to ensure its continued preservation. The house and grounds, located just southwest of town, are now open to the public by appointment. (Courtesy Library of Congress.)

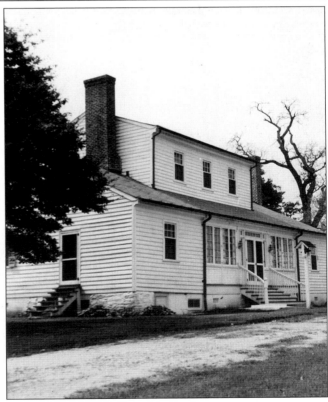

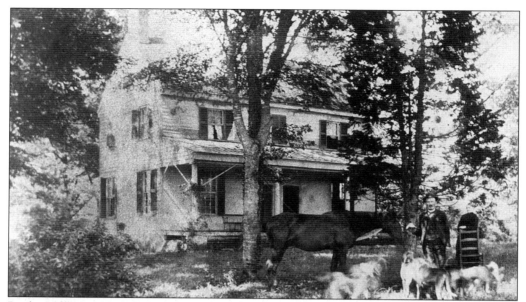

Poplar Hill was originally built in 1794 as the home of James Hogg on his farm just south of the Eno River. Hogg, born in Scotland, arrived in North Carolina in 1774 and soon became a prosperous businessman. He was also one of the first trustees of the University of North Carolina. Poplar Hill was later remodeled to serve as the main house for Gen. Julian Carr's Occoneechee Farm. Eventually falling into disrepair, the house was moved north across the river in 1980 and restored by James Freeland. (Courtesy of Hillsborough Historical Society.)

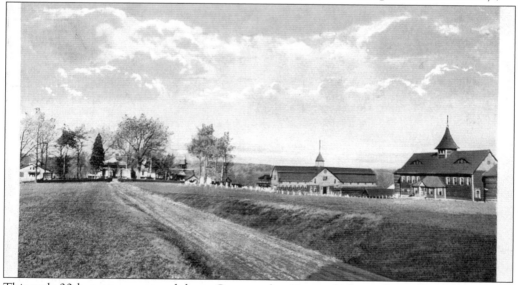

This early 20th-century postcard shows Occoneechee Farm, which was located on what is today Highway 70 Business. Originally known as Poplar Hill, the estate was purchased in the 1890s by wealthy industrialist Gen. Julian Carr, who turned the property into a thriving farm. In a 1919 tornado, the barns and outbuilding suffered severe damage and the farm never recovered. The land was sold for housing development in 1923 and the main house was eventually moved. (Courtesy of Hillsborough Historical Society.)

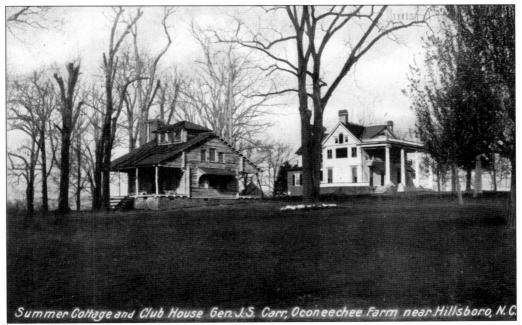

This early 20th-century postcard shows the summer cottage and clubhouse at Occoneechee Farm. (Courtesy of Hillsborough Historical Society.)

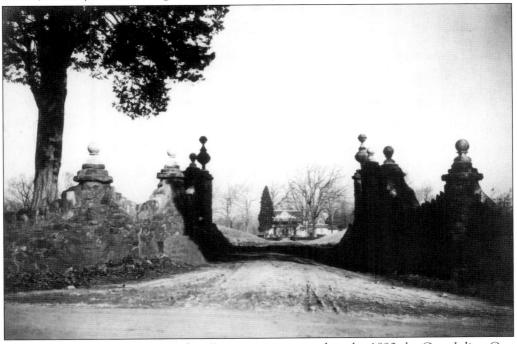

The stone entryway to Occoneechee Farm was constructed in the 1890s by Gen. Julian Carr when he purchased and remodeled Poplar Hill. Though the house has been moved and estate is now a housing development, the stone entrance still exists on Highway 70 Business. (Courtesy of North Carolina Collection, University of North Carolina Library at Chapel Hill.)

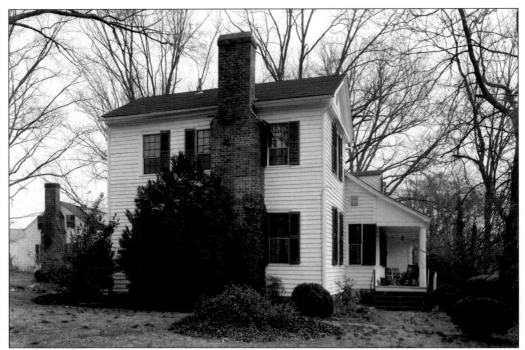

The central part of Heartsease on East Queen Street, seen here in two views, was built by Sterling Harris *c.* 1786. In 1834, the house was purchased (and named) by Dennis Heartt, editor of the *Hillsborough Recorder*, the town newspaper. In the attic of the house, Heartt had a room that was often occupied by his apprentices. One who probably stayed there, William H. Holden, went on to become a North Carolina governor. (Courtesy Library of Congress.)

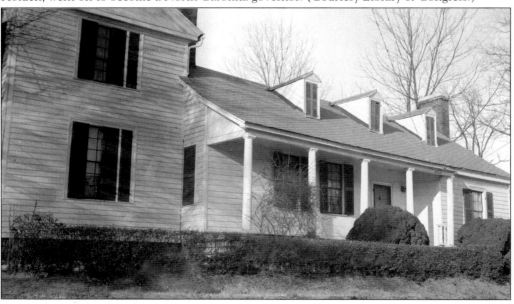

A longtime owner of Heartsease, newspaper editor and printer Dennis Heartt (1783–1870) was born in Connecticut and moved to Hillsborough from Philadelphia around 1820. He soon established *The Hillsborough Recorder*, which became the most well-known (and politically influential) newspaper in the region. Heartt continued as the paper's publisher well into his 80s before selling it in 1869. (Courtesy Orange County Historical Museum.)

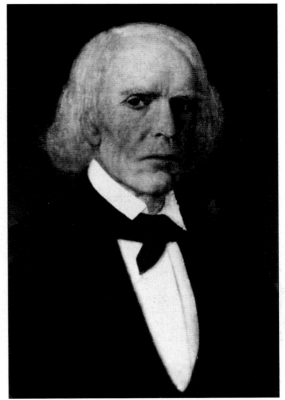

One of Hillsborough's oldest surviving homes, Twin Chimneys was probably constructed around 1770. Named for the large pair of chimneys on each of its ends, the West King Street house was confiscated from Tory leader (and later British general) Edmund Fanning during the Revolutionary War. One of the home's other claims to fame is that is was the setting for a 1901 novel, *Joscelyn Cheshire*, written by Sara Beaumont Kennedy. (Courtesy Orange County Historical Museum.)

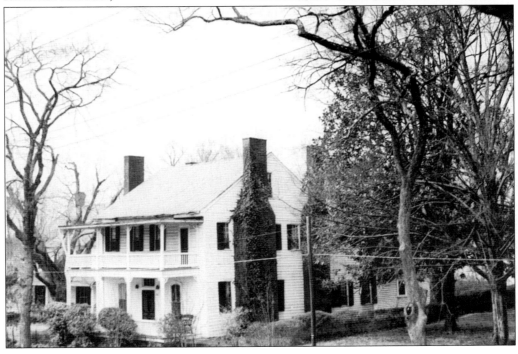

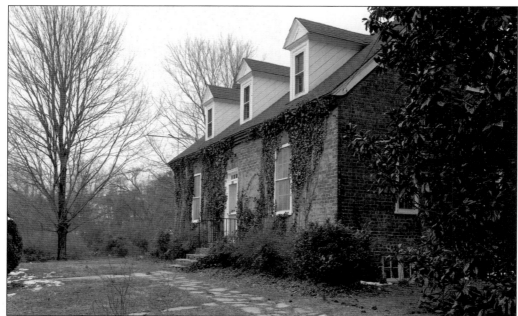

Built in 1805, the Berry Brick House on West Queen Street is the earliest brick dwelling in Hillsborough. Originally the home of Rhoda Berry and her son John, who would later go on to become a prominent architect and builder in the town, the house is a simple story-and-a-half structure with five fireplaces. Shown here as it appeared in 1965, the house has recently been enlarged and restored. (Courtesy Library of Congress)

This c. 1930s photo shows the house a couple miles west of town in which Thomas Hart Benton was born in 1782. Benton grew up in the area, but he and his family moved to Tennessee in 1799. Later, after becoming a prominent attorney, he moved on to Missouri where he was elected as the new state's first senator. Benton served 30 years in the Senate and was a major proponent of westward expansion by the United States. (Courtesy of North Carolina Collection, University of North Carolina Library at Chapel Hill.)

Though Hillsborough is known for its fine large homes, most of the town's residents have always lived in more modest dwellings. This log cabin, seen in a 1930s photo, was located on Margaret Lane, east of Churton Street. (Courtesy of North Carolina Collection, University of North Carolina Library at Chapel Hill.)

Seven Hearths, located on East King Street, is another of Hillsborough's great historic homes. With a central portion dating back to the 1790s, the house was apparently added on to at least twice more in the 1800s and it now consists of five different levels. Over the years, the home, seen here in a 1965 photograph, has had several prominent owners including Thomas Watts, the sheriff of Orange County from 1823 to 1832. Freedman Africa Parker operated a "still-house" along the creek on the western edge of the lot c. 1800. (Courtesy Library of Congress.)

Young Arlene King holds infant Clifford Heffner in this 1946 photo taken in the mill village on Eno Mountain. The home of Ida and Lee Medlin, typical of the style of house found in West Hillsborough, can be seen in the background. (Courtesy of Kathleen King Wagner.)

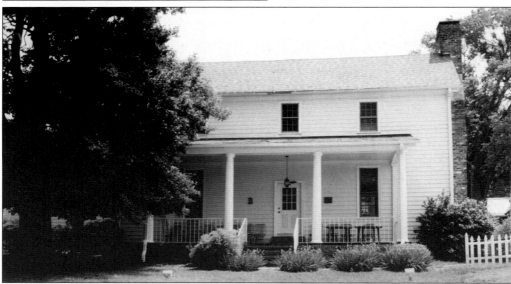

"George Washington slept here" is frequently heard in connection with pre-1800 houses. Those claims often prove false, but in the case of the Gatewood House, it is a fact documented in Washington's own diary. In June 1791, while on his tour of the South, he spent the night at the farm of Whit Gatewood. At that time, however, the house was located some miles to the north near Yanceyville. Moved to Hillsborough by James Freeland and restored in 1978, the house is now home to Casa Ibarra, a Mexican restaurant. (Photo by Bitsy McKee.)

Two

CHURCHES AND
SCHOOLS

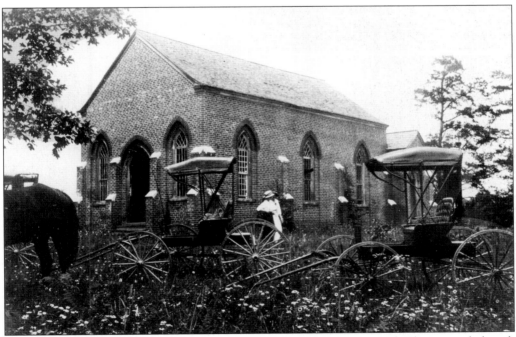

St. Mary's Chapel is located a few miles east of town on St. Mary's Road. The original chapel, located just a few yards from the one that now stands, was built in 1759 and was the earliest Church of England in the region. The present brick building, seen c. 1900, was erected in 1859. Services were discontinued at the chapel in the 1930s; today it is only used during a yearly Homecoming event. (Courtesy of North Carolina Collection, University of North Carolina Library at Chapel Hill.)

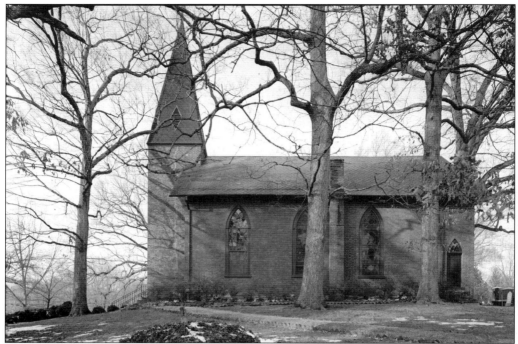

St. Matthew's Episcopal Church, located on St. Mary's Road, is a very early example of gothic architecture in North Carolina. Built in 1825–1826 with the entrance tower added in 1830, it was probably the work of architect John Berry. Interior and exterior views on this page show the church as it appeared in the 1960s. It remains relatively unchanged today. (Courtesy Library of Congress.)

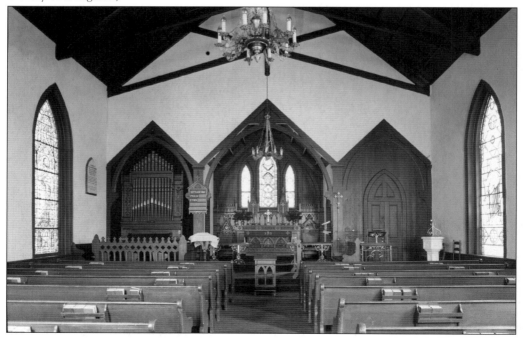

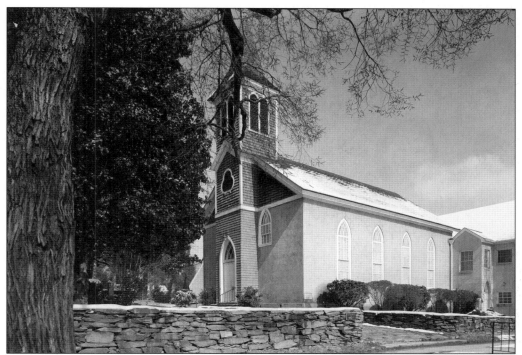

Built in 1816, Hillsborough's Presbyterian Church is the oldest Presbyterian church building in North Carolina (and possibly the country) in which services have been continually held. It was constructed on the site of the 1766 Church of England in which the Third Provincial Congress (1775), three General Assemblies (1778, 1782, 1783), and the Constitutional Convention of 1788 were held. (Courtesy Library of Congress.)

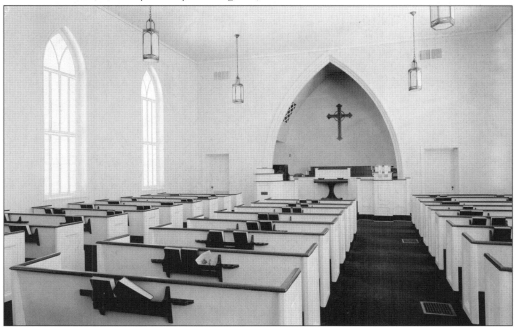

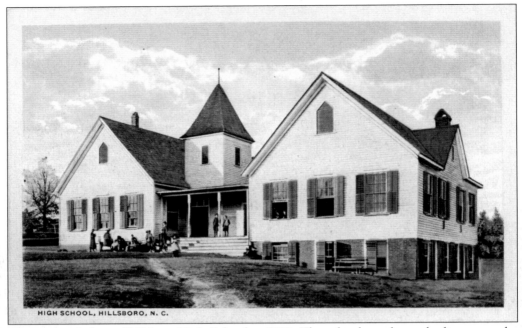

HIGH SCHOOL, HILLSBORO, N. C.

This postcard shows Hillsboro High School c. 1900. The school was located adjacent to the site where the new brick high school was constructed in 1922. (Courtesy of Hillsborough Historical Society.)

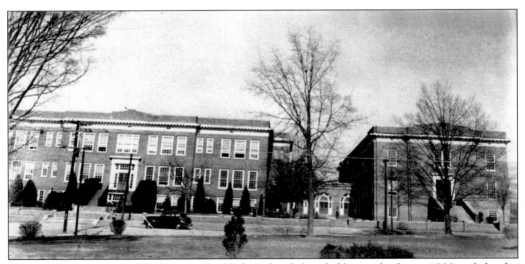

The original section of Hillsborough High School (on left) was built in 1922, while the addition was constructed in 1937. The building, which now houses the town library and other municipal offices, served as the high school until the early 1960s, when the new Orange High opened. (Courtesy of Chandler Cates)

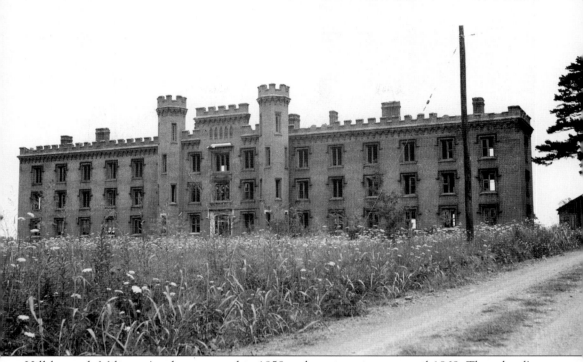

Hillsborough Military Academy opened in 1858 and was in existence until 1869. The school's founder and commandant, Col. Charles Tew, envisioned a North Carolina version of the Citadel, his alma mater. Unfortunately, his dream died when he was killed at the Battle of Sharpsburg in 1862. The school's castle-like, three-story brick barracks building, shown here neglected and abandoned in 1937, once housed close to 200 students. It was razed not long after this photo was taken and the bricks were used for other construction projects around town. (Courtesy Library of Congress.)

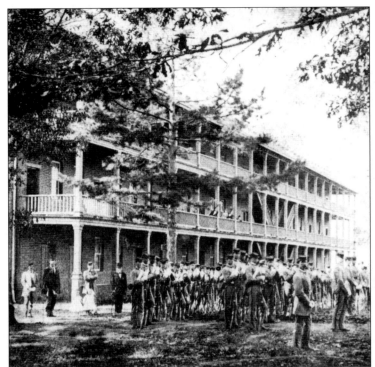

Cadets are pictured drilling on the parade grounds at Hillsborough Military Academy. (Courtesy of North Carolina Collection, University of North Carolina Library at Chapel Hill.)

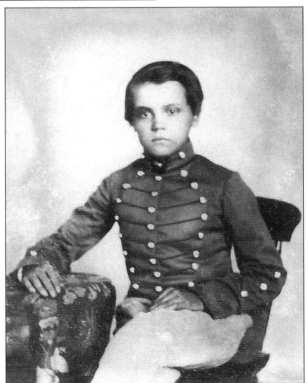

This young Hillsborough Military Academy cadet is unidentified. (Courtesy of Orange County Historical Museum.)

All-Saints Anglican Church on Barracks Road, built c. 1859, probably originally served as the chapel for Hillsborough Military Academy. After falling into disrepair, the building was restored in the early 1990s and services have been regularly held since Christmas Eve 1992. (Photo by the author.)

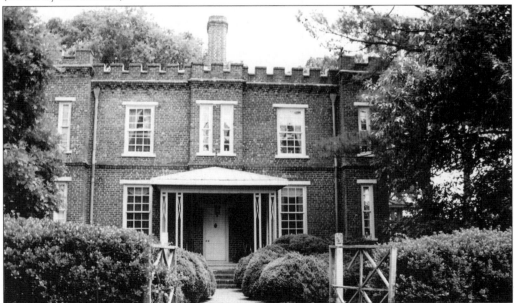

Built in 1859, the Commandant's House was just that—the home of the commandant of Hillsborough Military Academy. Col. Charles Tew, who founded the academy, was the original occupant of the house. Like the academy building, which was located across the street, the house fell into disrepair in the years after the school's closing. Fortunately, it was saved when it was purchased and restored by Lucius Cheshire in the 1960s. (Photo by the author.)

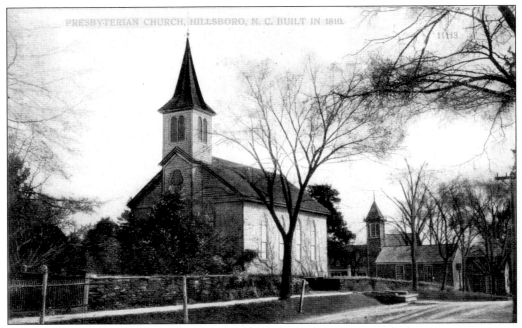

A late 19th-century postcard shows the Presbyterian Church and the Sessions House.
(Courtesy of Hillsborough Historical Society.)

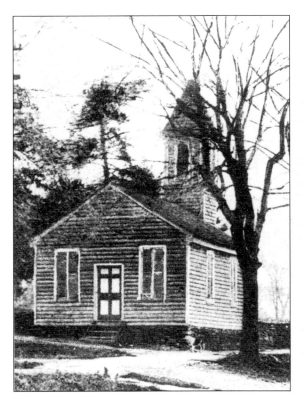

The Presbyterian Church's Sessions House, used for church meetings, was built in 1835 at the corner of Churton and Tryon Streets. Later the town's public library, it was the first in North Carolina to be supported by the citizens instead of the government. In 1934, the Sessions House was torn down and replaced by the Confederate Memorial Library. (Courtesy of Orange County Historical Museum.)

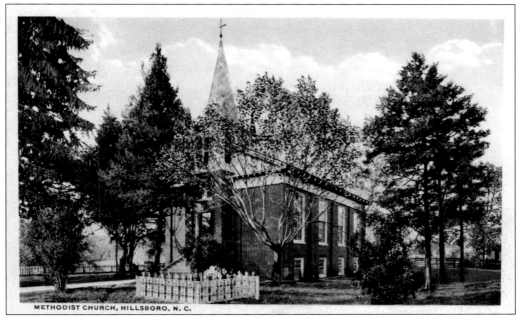

This *c.* 1900 postcard shows the Methodist Church on West Tryon Street. Built in 1859, the church is the only one in Hillsborough known to have been designed and built by John Berry. (Courtesy of Hillsborough Historical Society.)

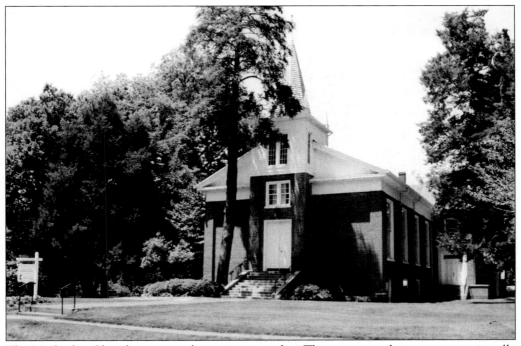

The Methodist Church is pictured as it is seen today. The attractive design remains virtually unchanged from its original appearance. (Photo by the author.)

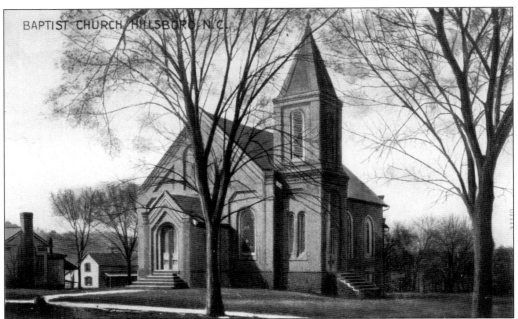

Hillsborough's First Baptist Church, located on Wake Street, is shown in an early 20th-century postcard. Construction on the Romanesque-design brick church began in 1860 but was halted due to the Civil War. It was finally completed in 1870. (Courtesy of Hillsborough Historical Society.)

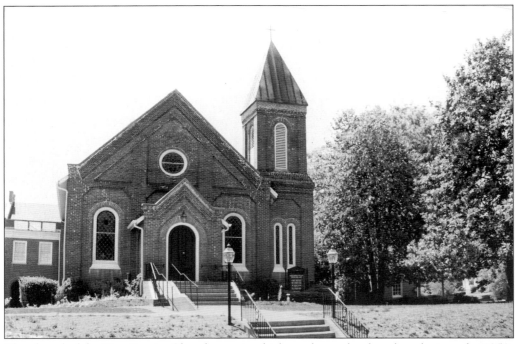

The chapel of the First Baptist Church remains fairly unchanged today, though since the 1950s several additions have been made to the rear and side of the building (Photo by the author.)

Annie Bell Wright Clark and her sister Margaret Wright Whitted are seen here in front of the Hillsboro Colored School c. 1950. The school, which was in operation until desegregation in the 1960s, was located at the corner of Nash and Union Streets, the site of Hillsborough Elementary today. (Courtesy of Margaret Whitted.)

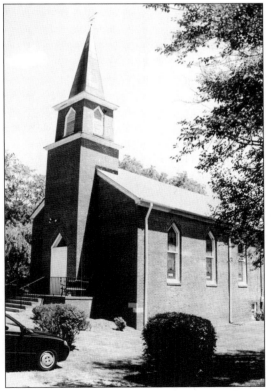

Dickerson's Chapel A.M.E Church on the southeast corner of Churton and East Queen Streets began life in 1790 as the Orange County Courthouse. In 1845, when a new brick courthouse was built, the old building was purchased by Baptist minister Elias Dodson. He then had the old frame building rolled intact up Churton Street to its present location and converted into a Baptist church. The Baptists discontinued use of the church during the Civil War and in 1862, it was purchased by three Philadelphia friends of the colored freemen of Hillsborough for use as the A.M.E. Church. The building was remodeled in 1891 and again in 1947 when the exterior was bricked over. (Photo by the author.)

Maria Jane Nash (1819–1907) and Sally Nash Kollock (1811–1893) were principals of the Nash-Kollock School for girls. The prestigious school was located on the south side of West Margaret Lane and was in operation from 1859 until the 1890s. (Courtesy of Hillsborough Historical Society.)

William J. Bingham (1802–1866) was a member of the distinguished Bingham family of educators. Born in Orange County, he studied at Bingham School, a preparatory academy for boys founded by his father and located for a time in Hillsborough. Soon after graduation from the University of North Carolina, Bingham became headmaster of Bingham School. His two sons, William and Robert, both of whom were born in Hillsborough, would later join their father in the running of Bingham School. (Courtesy of Orange County Historical Museum.)

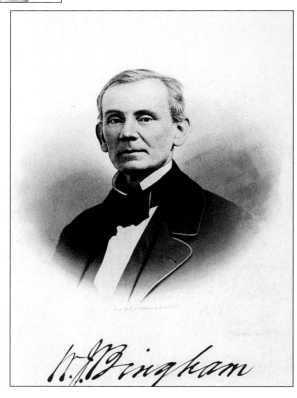

The two photos on this page show unidentified groups of students of Cedar Grove Academy, a school located just north of town. Originally named Hughes Academy, it was run by Samuel W. Hughes from the mid-1800s until his death in 1884. The school was then renamed Cedar Grove Academy and remained in operation until 1914. (Courtesy of Orange County Historical Museum.)

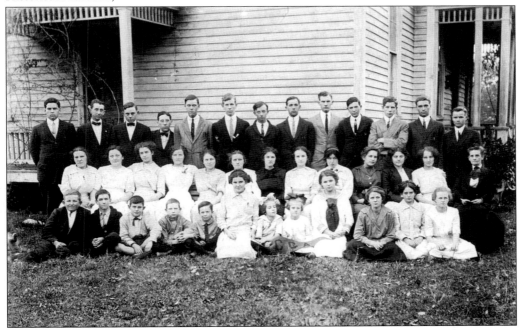

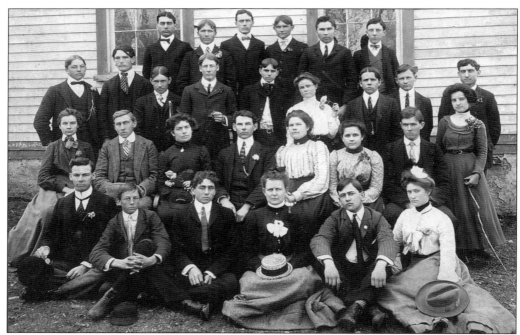

A group of unidentified students, probably from Hillsboro High School, are shown in a c. 1900 photo. (Courtesy of Orange County Historical Museum.)

Presbyterian minister Robert Burwell and his wife Margaret operated the Burwell School for girls from 1837 to 1857. Girls from ages 8 to 18 came from across the region to study at the prestigious school. The original part of the main house was built in 1821 and the Burwells had it enlarged by local builder John Berry in 1848. A few of the buildings associated with the school no longer exist but the Hillsborough Historic Commission began restoration of the main house in the mid-1960s and today the property is open to the public. (Photo by the author.)

Three
BUSINESS AND INDUSTRY

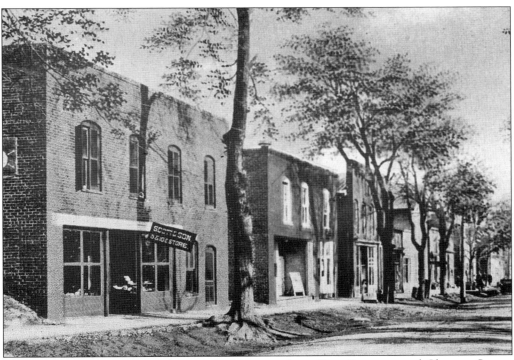

This c. 1920s postcard shows the view looking east down King Street toward Churton Street. At far left is the five-and-dime store, run by J.C. Scott and son, that also doubled as a funeral home. To the right of that building was the movie theater. (Courtesy of Hillsborough Historical Society.)

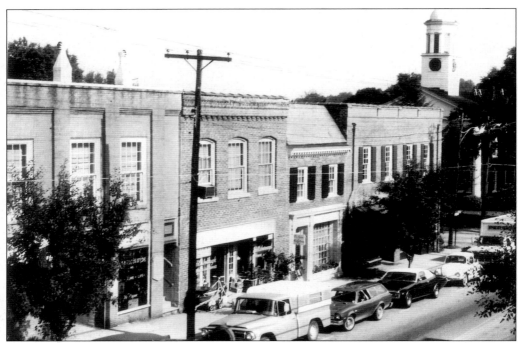

This view shows the businesses on the west side of Churton, looking south toward King Street, in the early 1970s. (Courtesy of North Carolina Collection, University of North Carolina Library at Chapel Hill.)

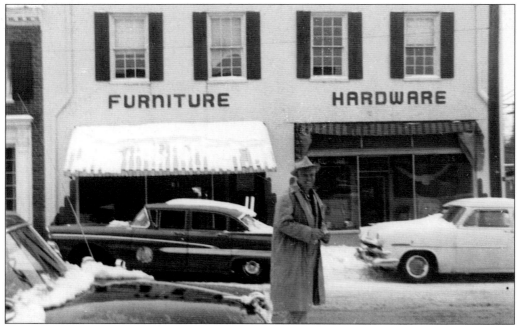

Hillsborough businessman James Freeland is seen here in front of Mitchell's Furniture and Hardware in a 1950s photo. The store was located on the northeast corner of Churton and King Streets. (Courtesy of Donna Freeland.)

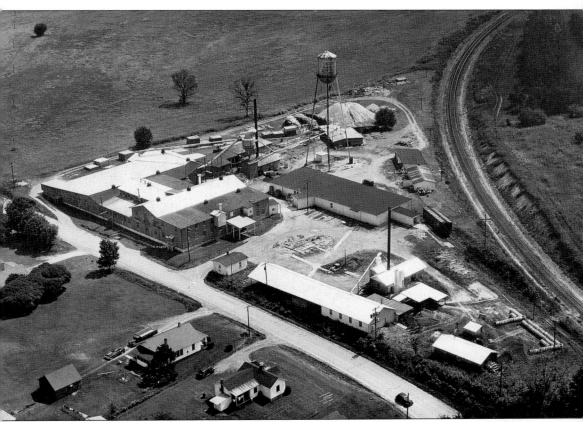

Orange Furniture Craftsmen, shown here in a *c.* 1950 photo, began producing quality furniture on Highway 70-A in the 1920s. Later purchased by White Furniture Co., the facility shut down in the late 1980s. Today, the complex, though much changed in appearance, is again home to one the town's largest employers. Sports Endeavors, Inc., a catalog retailer of soccer and lacrosse equipment has operated at the site since 1991 and now employees over 400 people. (Courtesy of Sports Endeavors, Inc.)

The Colonial Inn, seen here in a late 1800s photo that is looking east down King Street toward Churton Street, is one of Hillsborough's most recognizable buildings. The exact age of the building is not know but an inn or tavern has stood on the site since the earliest days of the town. The oldest parts of the present building probably date back to at least Spencer's Tavern in 1838. The establishment, reportedly the longest in continuous operation until it closed in 2001, has also been known as the Orange Hotel, the Occaneechi Hotel, and the Corbinton Inn. (Courtesy of Orange County Historical Museum.)

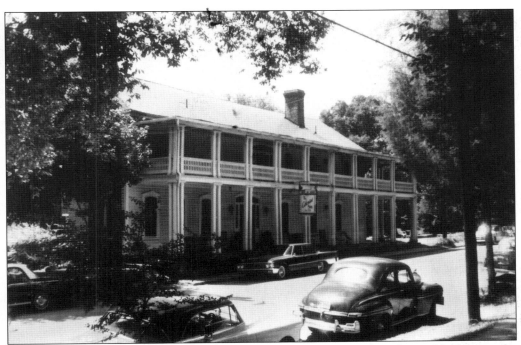

The appearance of the Colonial Inn, seen here in a 1950s photo, has changed little over the years. Though it closed in 2001, the inn was purchased by a new owner in 2002 and there are reportedly plans to renovate and reopen it. (Courtesy of Hillsborough Historical Society.)

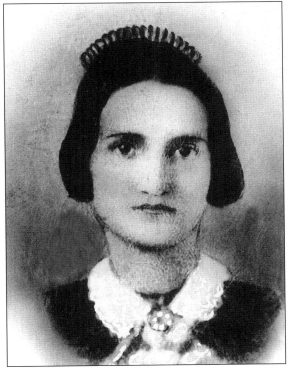

This portrait shows Octavia Strowd, who, along with her husband Calvin, was innkeeper at the Colonial Inn. During the closing days of the Civil War, some of General Sherman's Union troops visited Hillsborough and began ransacking the inn. According to local tradition, Mrs. Strowd found the Masonic apron that belonged to her husband (who was away serving in the Confederate Army) on the floor after the soldiers left. She took the apron and waved it out the window where it was seen by a Union officer, who also happened to be a Mason. The officer ordered the soldiers to return everything they had taken and the inn came to no further harm. (Courtesy of Orange County Historical Museum.)

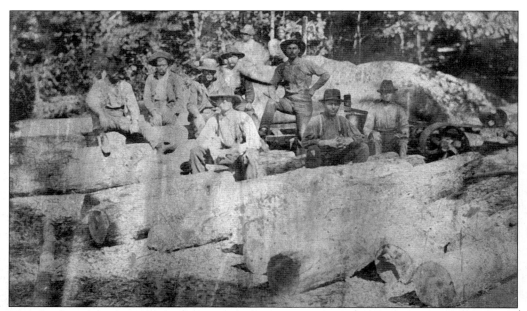

This Civil War–era tintype photo shows a logging crew in the Hillsborough vicinity. Due to the great pine forests of the area, the logging industry was important in the early years of the town. Not only used for lumber, the wood from trees was used for producing paper. In fact, the first paper mill in North Carolina was built in 1777 near where Churton Street crosses the Eno River. (Courtesy of Orange County Historical Museum.)

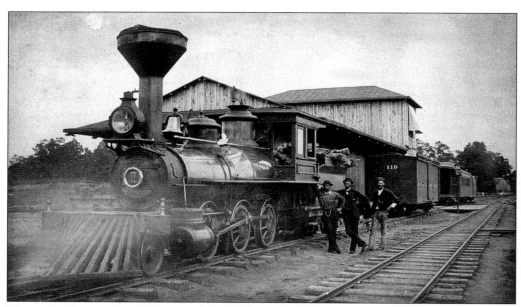

The railroad arrived in Hillsborough in the late 1850s. This photo shows a train and its crew stopped at the station in West Hillsborough sometime in the late 1800s. (Courtesy of Orange County Historical Museum.)

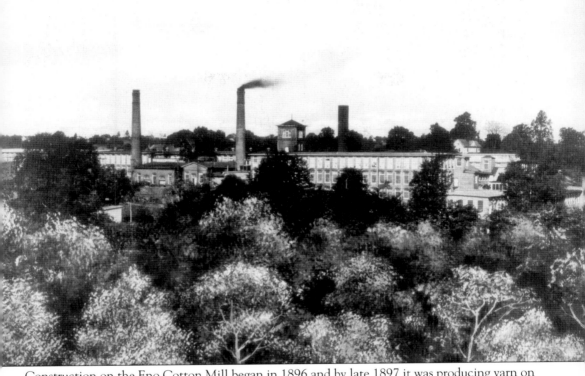

Construction on the Eno Cotton Mill began in 1896 and by late 1897 it was producing yarn on 10,000 spindles. The mill, located on the banks of the Eno River just below Occoneechee Mountain, thrived in the early years of the 20th century and played a large role in the growth of the town. Eventually, it became part of Greensboro-based Cone Mills. The changing fortunes of the textile industry eventually caught up with the plant and it was closed for good in 1984. (Courtesy of North Carolina Collection, University of North Carolina Library at Chapel Hill.)

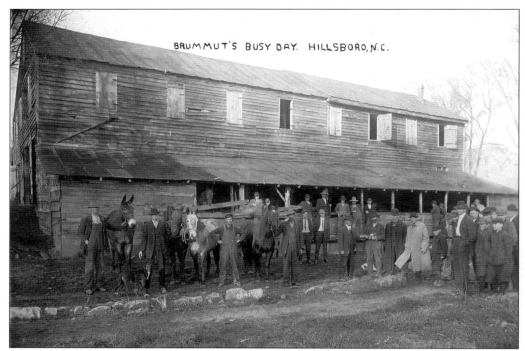

Brummut Brown ran a large livery stable just north of town. Here, in a c. 1920s photo, a crowd has assembled at the stable for an auction of horses and mules. (Courtesy of Hillsborough Historical Society.)

Walker's Funeral Home on North Churton Street has been serving town residents since the early 1900s. It is shown here in the early 1950s, before the building was remodeled to its present appearance. (Courtesy of Chandler Cates.)

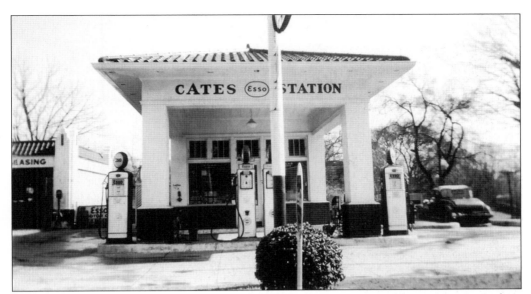

Cates' Esso Station was located on the northeast corner of Churton and Tryon Streets. Built in 1928, the station was torn down and completely rebuilt in 1956. (Courtesy of Chandler Cates.)

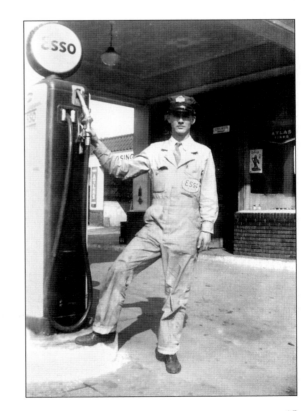

Chandler Cates, who would later serve as Hillsborough's fire chief, poses with one of his gas pumps in the mid-1940s. He ran Cates' Esso Station on Churton Street from 1942 to 1968. (Courtesy of Chandler Cates.)

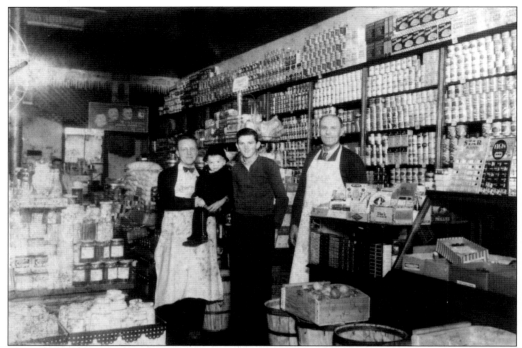

The photos on this page show two 1930s interior views of Forrest Brothers Grocery on West King Street. The same people are in both photos. They are, from left in the upper photo, Vincent "Chunk" Forrest, Bobby Forrest, Marshall Cates Jr., and Marshall Cates Sr. (Courtesy of Chandler Cates.)

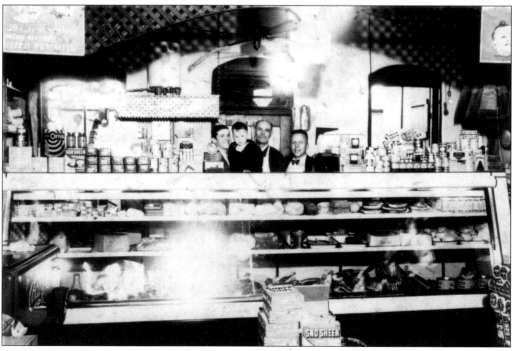

Music store owner June Haas poses with customer Melvin Beasley, who won a drawing for a clock, in a c. 1978 photo. Haas, whose husband Bob was the music director at Orange High School, ran the King Street store for several years. Melvin Beasley would later serve on the Orange County Board of Elections. (Courtesy of Marsha Stanley.)

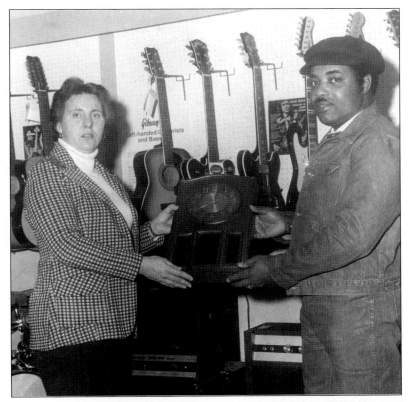

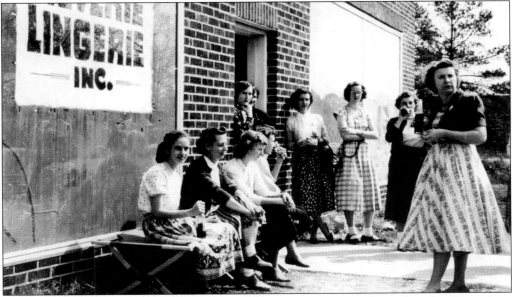

Reverie Lingerie, Inc. was located on Highway 70 West. Here, workers take a break not long before the entire factory burned to the ground in a mysterious fire during a 1957 strike. Identified are Mary Lou Albright (farthest left), Margaret Bateman (third from left), and Ruth Horne (second from right). (Courtesy of Marsha Stanley.)

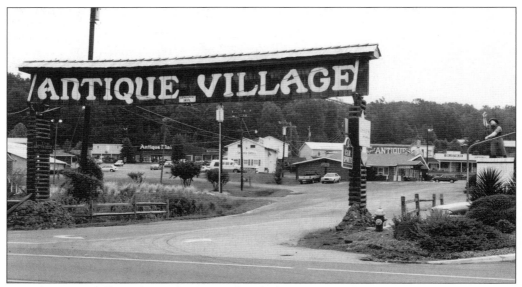

Daniel Boone Village, located just north of Interstate 85, features numerous businesses, particularly antique stores. The complex was constructed in the 1960s. (Courtesy of Hillsborough Chamber of Commerce.)

Vietri is an importer of fine Italian ceramics and glassware located in Hillsborough. Twice a year, the company draws huge crowds —rain or shine—to the warehouse sales it holds at its location on Elizabeth Brady Road. (Photo by Bitsy McKee.)

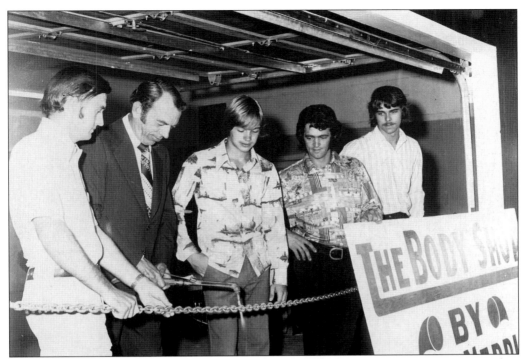

The Body Shop, which repaired auto bodies, was located in the Daniel Boone complex. Pictured from left to right, owner Carl Merritt, Mayor Fred Cates, Kirk Woods, Bobby Utsman, and William Crabtree take part in the 1975 grand opening ceremony. Carl Merritt later opened a successful boat dealership, Merritt Marine, on Highway 86. (Courtesy of Marsha Stanley.)

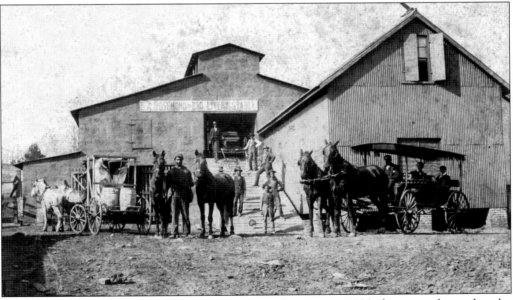

The E.A. Rosemond and Bro. Livery Stable, shown here in a c. 1900 photo, was located at the southeast corner of Churton Street and Margaret Lane. Today, the site is occupied by the new Orange County Courthouse. (Courtesy of Orange County Historical Museum.)

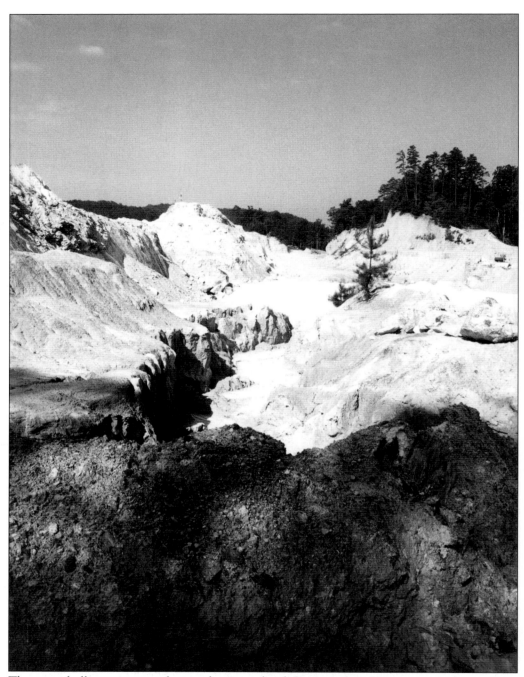

The pyrophyllite mine on the northeast peak of Occoneechee Mountains is shown here. Rare and mined in only two states, pyrophyllite (aluminum silicate hydroxide) is similar to talc and has many properties that make it useful in the manufacturing of ceramics and refractors. It is also used as joint compound filler and in the paint and insecticide industries. The minerals found in Hillsborough are world famous for their quality. (Courtesy of Hillsborough Chamber of Commerce.)

Four
HILLSBOROUGH PEOPLE

Hillsborough residents Haywood and Alice King (holding Ruby) pose with 6 of their 15 children in 1917. The children are, from left to right, Marvin, Bill, Martha, Artis, and Henry. (Courtesy of Kathleen King Wagner.)

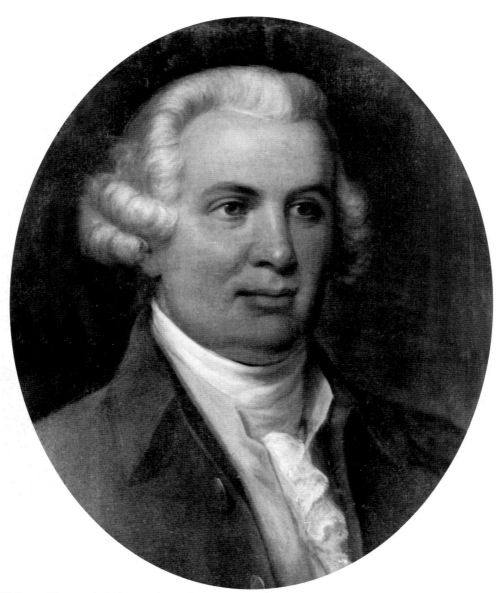

William Hooper (1742–1790) was born in Boston and educated at Harvard, but upon passing the bar exam he moved to Wilmington, North Carolina. Thanks to his popularity and leadership abilities, Hooper soon became a prominent figure in North Carolina politics. In 1770, he was appointed the Colony of North Carolina's deputy attorney general and in 1773 he was elected to the colonial legislature. Hooper was a great opponent of British rule and, as the movement toward independence grew, in 1774 he was elected to a seat in the Continental congress. During his time in congress he signed the Declaration of Independence, but the following year he resigned his seat and returned to North Carolina, where he felt he was needed. Harassed by the British in Wilmington, Hooper moved with his family to Hillsborough during the war and in 1781 he purchased the home now known as the Nash-Hooper house. He remained in Hillsborough until his untimely death at age 48 and was buried in the town cemetery. (Courtesy of Hillsborough Historical Society.)

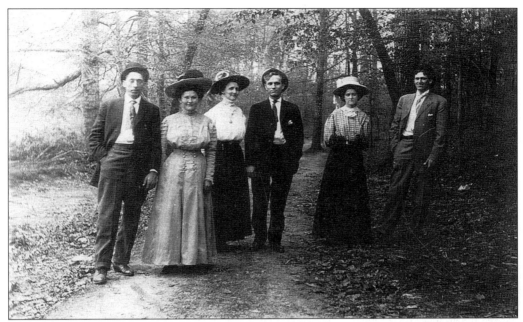

Town residents take a stroll on the Dark Walk, c. 1900. The scenic path along the banks of the Eno River was a popular spot for many years. (Courtesy of Orange County Historical Museum.)

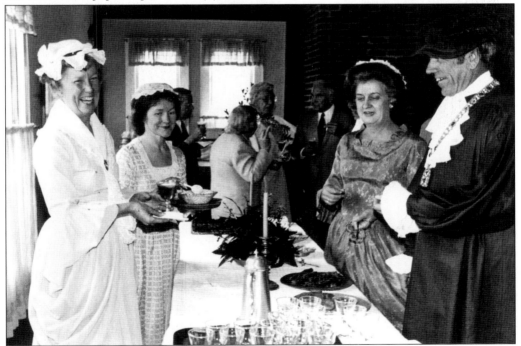

Hillsborough residents are dressed in Colonial-era garb for a reception at the Colonial Inn after a 1981 ceremony commemorating Lord Cornwallis' stay in the town. In the foreground, from left to right, are Hilda Brody, Priscilla Lane, Elizabeth Cates, and Mayor Fred Cates. (Courtesy of Hillsborough Historical Society.)

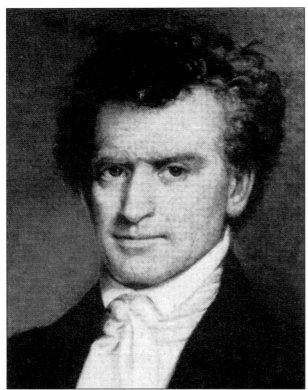

Thomas Ruffin Sr. (1787–1870) was born in Virginia and moved to Hillsborough in 1809 after graduating from Princeton and passing the bar exam. He represented Hillsborough in the state legislature from 1813 to 1816 and was a judge of superior court. In 1829, Ruffin became a justice of the North Carolina Supreme Court and he served as chief justice from 1833 to 1852. Ruffin's son, Thomas Jr., was also a prominent Hillsborough lawyer and state Supreme Court justice as well as a lieutenant colonel in the Confederate Army. (Courtesy of Hillsborough Historical Society.)

From left, Emma Sue Loftin and her husband, attorney Dalton Loftin, are pictured at a 1960s dinner party with Mr. and Mrs. Jim Coleman, owners of a Durham lumber company. (Courtesy of Marsha Stanley.)

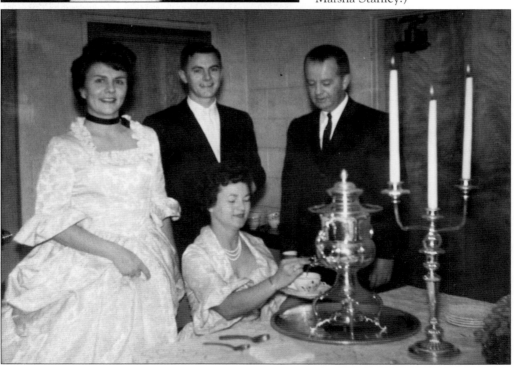

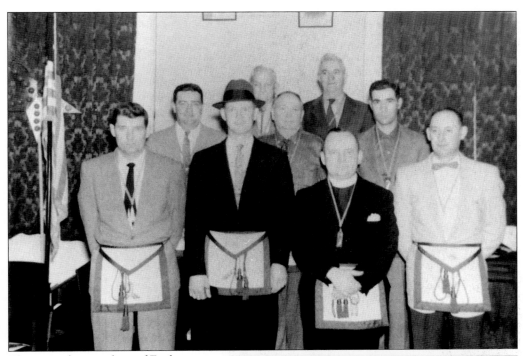

These are the members of Eagle Lodge #19 in 1959. From left to right are (front row) Delmar Brown, Chandler Cates, Lawton Pettit, and Charles Williams Jr.; (middle row) unidentified, John Mangum, and Harvey Gates; (back row) Will Smith and Hubert Bivins. (Courtesy of Chandler Cates.)

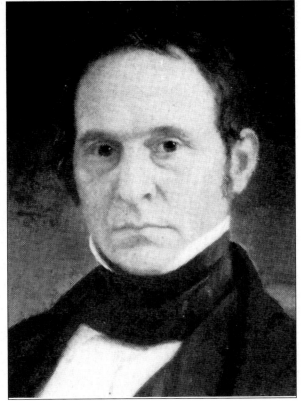

Willie P. Mangum (1792–1861) was born in Orange County, received schooling in Hillsborough, and graduated from UNC. He was admitted to the bar in 1817 and elected to represent Orange County in the general assembly the following year. In 1823, Mangum successfully ran for Congress and in 1831 was elected to the first of three terms as United States senator. One of the most respected legislators of his day, Mangum was president pro tem of the Senate from 1842 to 1845 and he even received the 11 electoral votes of South Carolina in the 1836 presidential election. (Courtesy of Hillsborough Historical Society.)

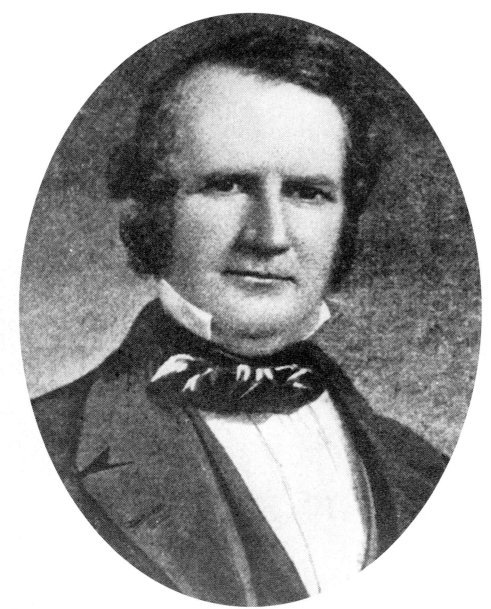

William A. Graham (1804–1875) had a long and distinguished career in public service. Born near Lincolnton, North Carolina, he studied law at UNC in Chapel Hill. Upon admittance to the bar in 1825 he established his law practice in Hillsborough. In 1833, Graham was elected to the North Carolina House of Commons and in 1840 he was elected to fill a vacant seat in the United States Senate. Graham successfully ran for governor of North Carolina in 1845 and after one term he was chosen to serve as secretary of the navy under President Millard Fillmore. In 1852, Graham was the Whig party nominee for vice president on the ticket with Winfield Scott. After his defeat in that election, Graham returned to North Carolina where he served in the state senate and later the Confederate Congress from 1864 to 1865. (Courtesy of Hillsborough Historical Society.)

Hillsborough natives Chandler and Margaret Cates, seen here in the mid-1940s, celebrated their 58th wedding anniversary in 2002. (Courtesy of Chandler Cates.)

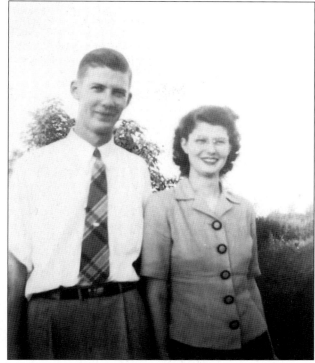

Pictured from left to right, West Hillsborough youngsters Mandy Webster, Darlene Andrews, Lee Andrews, and Donna Andrews pose for a photo in 1967. (Courtesy of Kathleen King Wagner.)

From left to right, Sue Hayes, unidentified, James Rae Freeland, and Joan Freeland, who all grew up in the Fairview section of Hillsborough, are shown here in the late 1940s. (Courtesy of Donna Freeland.)

Henry King and his brother-in-law Bud Culbertson are pictured in the Eno Mountain mill village in the early 1950s. King was well known around town as the pianist for several churches. (Courtesy of Kathleen King Wagner.)

Ruth Whitted stands in front of her car after a baseball game at McPherson's Park on Nash Street in 1949. (Courtesy of Margaret Whitted.)

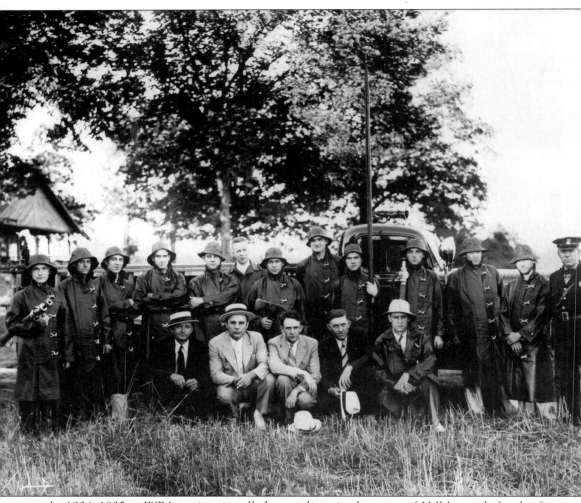

In 1934–1935, a WPA project installed water lines in the town of Hillsborough for the first time. As part of the same project, the WPA provided money to establish the town's first official fire department and purchase a truck for their use. This 1937 photo shows some of the town's first firemen. From left to right are (front row) Raney Roberts, Dr. Henry Moore, Edwin Lynch, Ben Johnson, and Chief George Gilmore; (back row) Marvin Walker, Herman Strayhorn, Curtis Rhew, Jim Gordon, Buck Knight, V.M. Forrest, Leonard Rosemond, Roger Wilson, Homer Watkins, Seth Thomas, Mitchell Lloyd, George Teer, and Harvey Watkins. (Courtesy of Chandler Cates.)

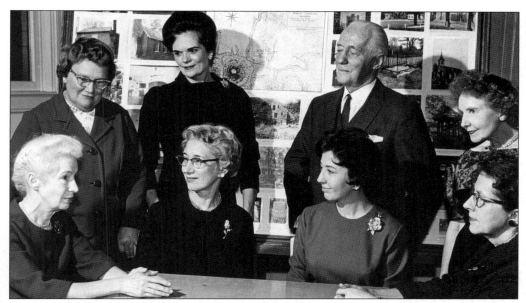

This is a mid-1960s meeting of the Hillsborough Historical Society. Seated, from left to right, are Mary Claire Engstrom, Mrs. Moore, Betty June Hayes, and Mrs. Jones. Standing are Bessie Collins, Marion Roberts, and Mr. and Mrs. Kellenberger, who apparently showed the group slides from a trip to Tryon Palace in New Bern. (Courtesy of Hillsborough Historical Society.)

Seen in 1960 (left to right) are Margaret Whitted, William Whitted, Warren Whitted, Donald Whitted, Fannie Martin (Margaret's sister), and Lynn Martin. (Courtesy of Margaret Whitted.)

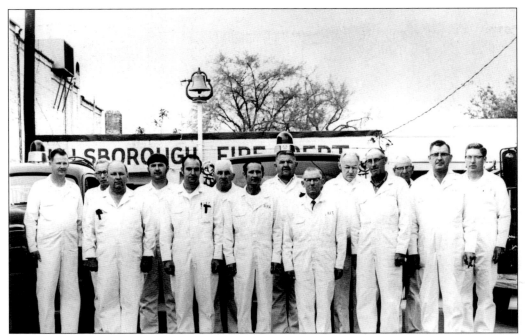

Hillsborough's Fire Department was strictly a volunteer organization until the late 1990s, when the growth of the town called for paid positions to be established. This photo shows the volunteers who served the town in the mid-1960s. From left to right are Chandler Cates, Marion Clark, John Lynch, Wayne Kendricks, Tyson Clayton, Brandon Lloyd, Allen Walker, Jr., J.E. Latta Jr., Ralph Thomas, Allen Lloyd, Charles Williams Jr., Chief George Gilmore, Foy Cole, and Sandy Davidson. (Courtesy of Chandler Cates.)

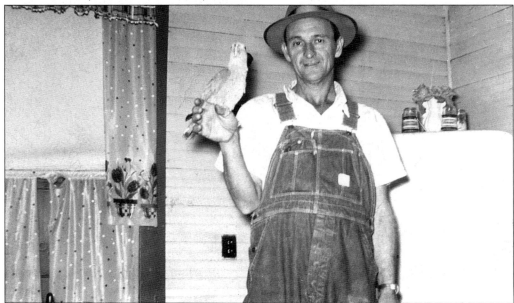

Mill village resident Henry King was known for his exotic pets, which included parrots and monkeys. Here he is seen in 1947 with his parrot Charlie. (Courtesy of Kathleen King Wagner.)

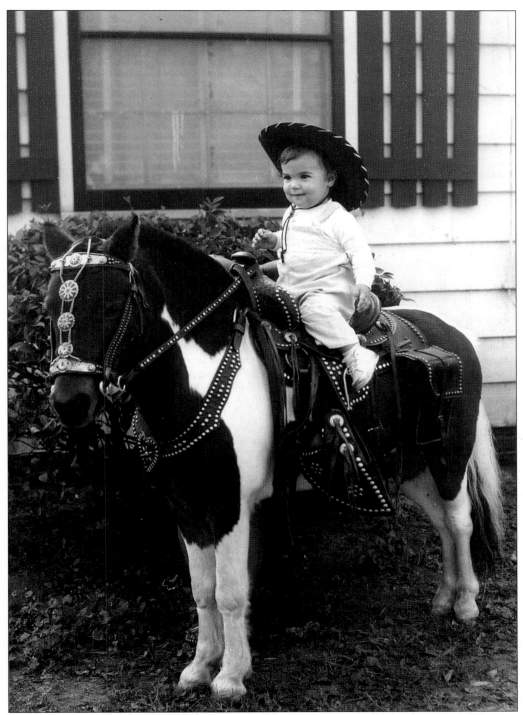

In the early 1960s a photographer came through Hillsborough offering parents a chance to purchase portraits of their children on his pony. Here two-year-old Mandy Webster does her best cowgirl impression. (Courtesy of Kathleen King Wagner.)

Prominent jazz pianist and composer Billy Strayhorn was born in Ohio and grew up in Pittsburgh but he spent many summers during his youth with his grandparents in Hillsborough. This c. 1950 photo shows his grandfather, Jobe Strayhorn (left) along with local theater owner Bill Chance. Billy Strayhorn is most famous for compositions including "Take the A Train" and his longtime collaboration with Duke Ellington. (Courtesy of Orange County Historical Museum.)

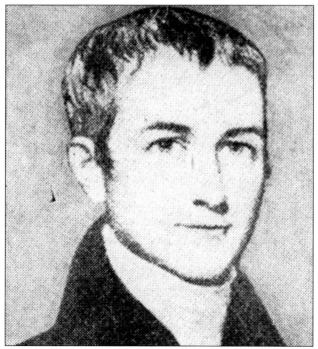

Archibald DeBow Murphey (1777–1832) was perhaps North Carolina's most progressive social reformer of the 19th century. A native of Caswell County, Murphey studied at UNC and established his law practice in Hillsborough in 1802. He was state senator of Orange County from 1812 to 1818 and, while in office, he championed a public education system for the state. Murphey was also an advocate of improved transportation and social conditions, and he encouraged more productive agriculture practices. He was later a judge of the Superior and Supreme Courts in the state as well as a trustee of the University of North Carolina. (Courtesy of Hillsborough Historical Society.)

A member of the Confederate Army, Orange County native Lorenzo Bennett died of disease during the Civil War. It was at his father's farm, a few miles east of Hillsborough, that the war effectively came to an end when Johnston surrendered to Sherman on April 26, 1865. Approximately 2,500 Orange County men served in the military during the Civil War. (Courtesy of Orange County Historical Museum.)

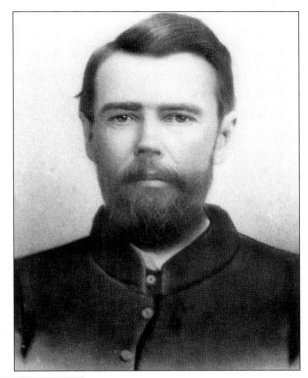

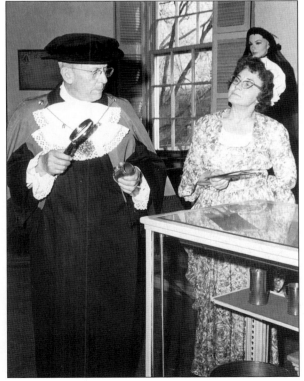

Edwin M. Lynch, longtime clerk of court in Hillsborough, is shown here in a 1960s photo dressed as the Colonial-era Keeper of the Weights and Measures. His fellow re-enactor is unidentified. Hillsborough's weights and measures, now on display at the Historical Museum, are the only complete 18th-century set in the United States. (Courtesy of Orange County Historical Museum.)

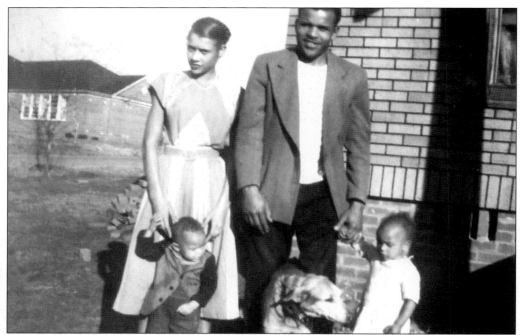

Margaret Whitted and her brother Earl Wright with youngsters Harvey Clark and Marinda Wright are pictured in front of their family's house near the intersection of Nash and Union Streets. (Courtesy of Margaret Whitted.)

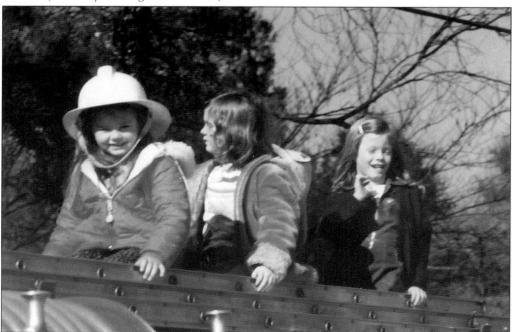

Cousins Christie Cates (left) and Marilee Reynolds (right) with an unidentified playmate (center) are shown on top of one of the town's fire trucks in the mid-1970s. (Courtesy of Chandler Cates.)

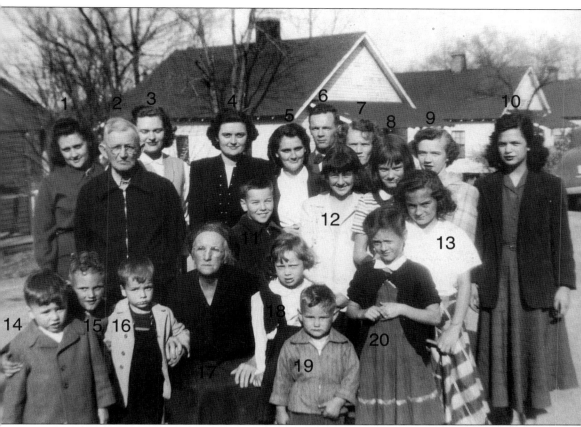

William and Nanny Snyder pose with their grandchildren at the home of Henry and Eula King in the Eno Mountain mill village in 1950. Gathered for the photo are 1) Estelle King Heffner, 2) William Snyder, 3) Elenore Stout Smith, 4) Wynell Stout Cooper, 5) Kathleen King, 6) Robert Culbertson, 7) Mickey Snyder, 8) Shelby Jean Snyder, 9) Evone Culbertson, 10) Nancy Snyder, 11) Wayne Brady, 12) Janice Brady, 13) Arlene King, 14) Kenneth Brady, 15) Clifford Heffner, 16) Donald Brady, 17) Nanny Snyder, 18) Linda Snyder, 19) Bobby Heffner, and 20) Ann King. (Courtesy of Kathleen King Wagner.)

Former Hillsboro High School classmates, from left to right, Grace Chance, Margaret Cates, Hannah Beard, Chandler Cates, Wanda White, Winnie Williams, Owen Ellison, and Violet Chance enjoy an outing at Duke Gardens in Durham *c.* 1943. (Courtesy of Chandler Cates.)

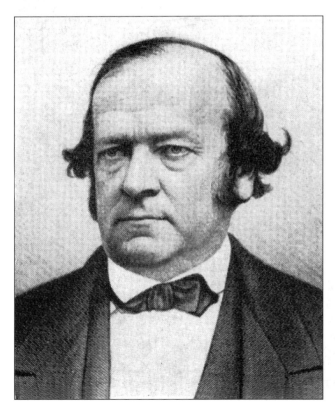

Josiah Turner Jr. (1821–1901) was one of Hillsborough's most prominent citizens in the mid-19th century. Born in the town, he studied at UNC, passed the state bar exam in 1845, and successfully ran for a seat in the state legislature in 1852. In 1861, Turner was a delegate at North Carolina's secession convention and he joined the Confederate Army upon the outbreak of war. Achieving the rank of captain, he was eventually wounded and forced to return home but he continued to serve the cause as a Confederate congressman. After the war, Turner remained active in state politics and served as publisher of the *Raleigh Sentinel*. (Courtesy of Hillsborough Historical Society.)

Cousins Horace Freeman (left) and Henry King (right) pose for a photo in the mill village in 1937. (Courtesy of Kathleen King Wagner.)

Pictured from left to right, local women Mrs. Doherty, Margaret Jones, Mary Roberts, and Thelma Johnson have a look at the Colonial costumes of Edwin Lynch (far right) and an unidentified associate. This 1960s photo was taken at the town museum when it was located in the old courthouse. (Courtesy of Orange County Historical Museum.)

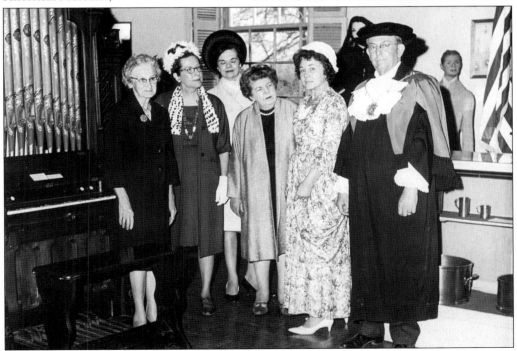

Young James Rae Freeland sits for a photo on the front porch of his family's home in the Fairview section of town *c*. 1943. (Courtesy of Donna Freeland.)

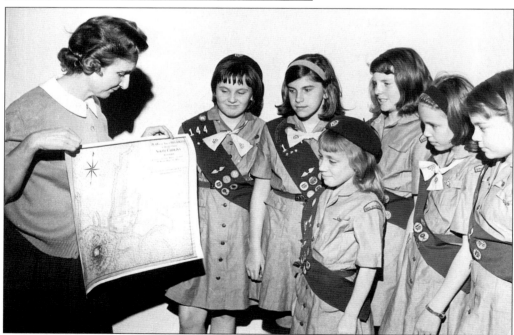

The unidentified members of a local Girl Scout troop are shown viewing the Sauthier map of Hillsborough in the 1960s. (Courtesy of Orange County Historical Museum.)

Hillsborough resident Pete Benton is shown in his army uniform, *c.* 1920s. Benton was a veteran of World War I. (Courtesy of Margaret Whitted.)

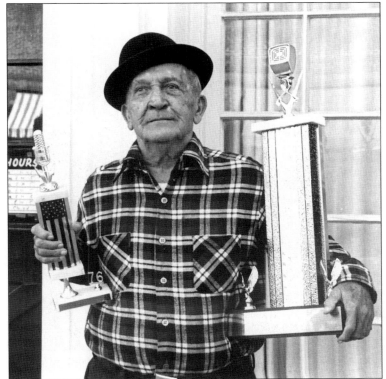

Hillsborough resident and amateur radio enthusiast George Waddell poses for a 1976 photo with his radio competition trophies. (Courtesy of Marsha Stanley.)

Members of the McPherson family gather for a reunion at the Nash Street home of Hayles "Butte" Payne in 1951. (Courtesy of Margaret Whitted.)

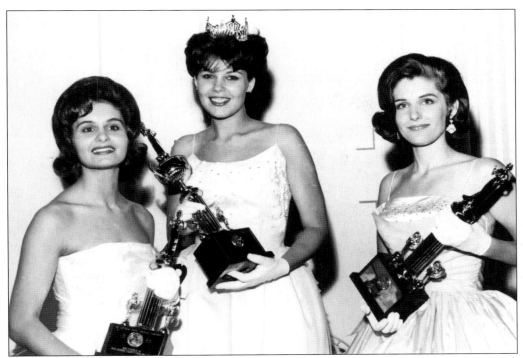

Hillsborough's Ann Clayton (center) won the title of Miss Orange County in 1963. Shown here with the unidentified runners-up, she went on to compete in the Miss North Carolina Pageant. (Courtesy of Marsha Stanley.)

Hilda Johnson and Edna Dawkins show a new addition to the town library in 1976. (Courtesy of Marsha Stanley.)

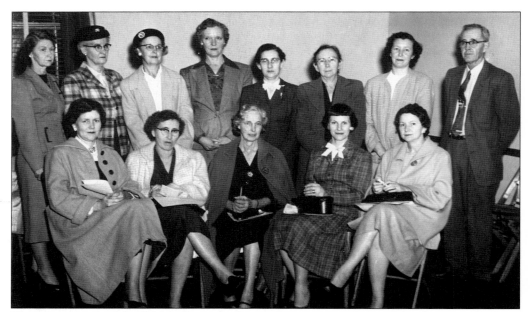

This is a meeting of the Schley Grange, a fraternal organization for rural families, c. 1960. From left to right are (front row) Frances Hamlin, unidentified, Beth Roberts, Mary Frances Pope, and Annie Roberts; (back row) Polly McKee, Maude McKee, Eva Kirkland, Margaret Gates, Georgia Latta, Sally Mincey, Trynis Nichols, and Allan Latta. (Courtesy of Marsha Stanley.)

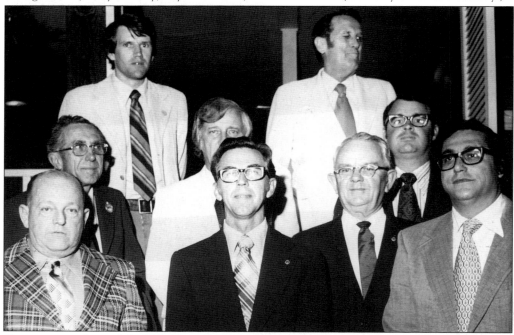

These are members of the Hillsborough Lions Club in an early 1970s group photo. From left to right are (front row) Roy Thomas, Robert Davis, Rev. Chester Andrews, and unidentified; (middle row) Van Kenion, unidentified, and Lester Ball; (back row) unidentified and Pete Thompson. (Courtesy of Marsha Stanley.)

Margaret Wright Whitted poses in front of one of the visible gas pumps at Watkins' Service Station on West Corbin Street, c. 1945. (Courtesy of Margaret Whitted.)

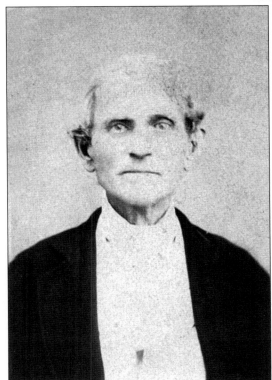

Lemuel Lynch (1808–1893) was a Hillsborough silversmith who kept a shop on King Street. A prominent civic leader as well, he served as mayor, both town and county commissioner, and Justice of the Peace at various times during his career. Lynch is also credited for putting the town clock back in running order after it had been in storage for 20 years. (Courtesy of Orange County Historical Museum.)

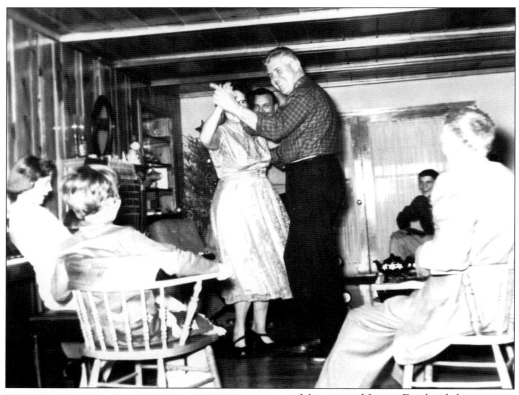

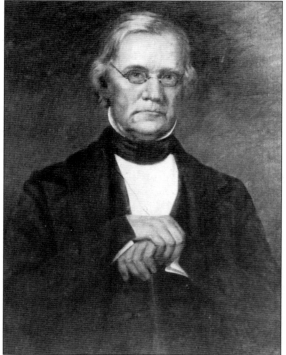

Maxine and James Freeland share a dance in front of family members at their Fairview home during a Christmas get-together in the mid-1950s. (Courtesy of Donna Freeland.)

The son of Abner Nash, North Carolina's second state governor, Frederick Nash (1781–1858) was born at Tryon Palace in New Bern. He was educated at Princeton but returned to North Carolina and established a law practice in Hillsborough in 1807. Nash spent several terms representing the town in the state general assembly and was also judge of superior court. He served on the state supreme court beginning in 1844 and was Chief Justice from 1852 until his death. (Courtesy of Hillsborough Historical Society.)

Two unidentified Hillsborough residents pose for a 1920s snapshot on top of one the columns at the entry to Occoneechee Farm on Highway 70 Business. (Courtesy of Marsha Stanley.)

William Whitted (center) is pictured with his four sons (from left to right) Donald, Warren, Robert, and Charles during a family get-together at Christmas, 1984. (Courtesy of Margaret Whitted.)

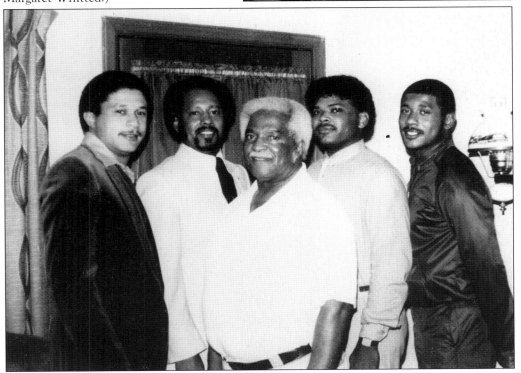

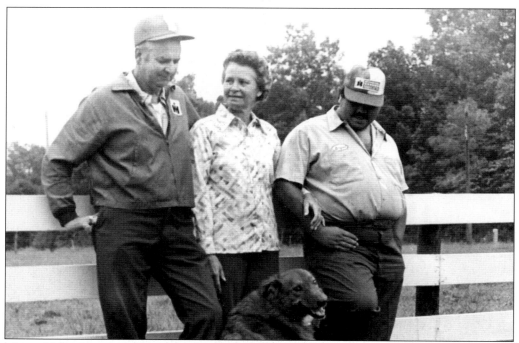

Mr. and Mrs. George Dodson and their son Bryan, seen here in a 1970s photo, ran a dairy just south of town. Their dog was famous for his ability to herd the cows into the barn for milking. (Courtesy of Marsha Stanley.)

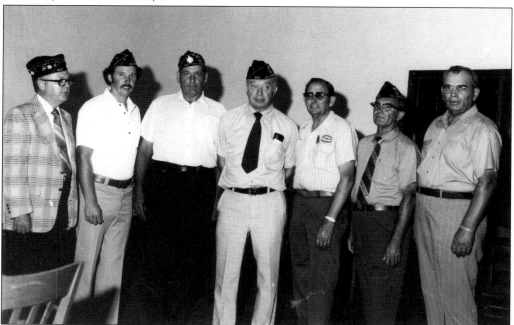

Hillsborough members of the Veterans of Foreign Wars gather for a c. 1970 photo. From left to right are Frank Ray, unidentified, Wallace Bacon, unidentified, Lester Ball, Frank Davis, and Aaron Thompson. (Courtesy of Marsha Stanley.)

Cash Boggs, seen here in a 1970s photo, was Hillsborough's dog warden for many years. (Courtesy of Marsha Stanley.)

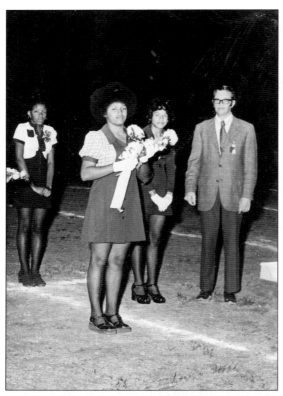

Members of Stanford Jr. High's Homecoming Court are shown here, *c.* 1980. From left to right are unidentified, Stephanie Whitted, Linda Wade, and Principal Wiley Shearin. (Courtesy of Margaret Whitted.)

Hillsborough resident Claire McDade tends her front porch garden in a 1960s photo. (Courtesy of Marsha Stanley.)

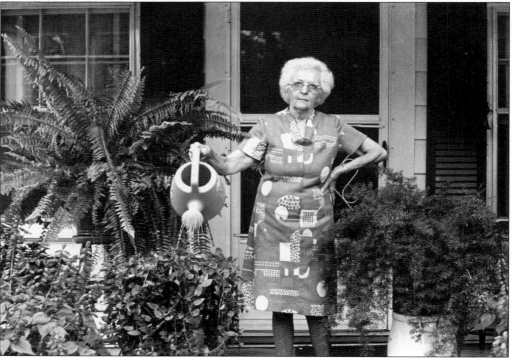

Kathleen King Wagner worked in the weave room of the mill for many years. Here she is seen at her parents' house in the mill village in 1948. The home of Ida Medlin is in the background. (Courtesy of Kathleen King Wagner.)

Clara Poole, Betsy Smith, and Melba Walker, who worked in the lunchroom at Orange High School, were familiar faces to many students over the years. (Courtesy of Marsha Stanley.)

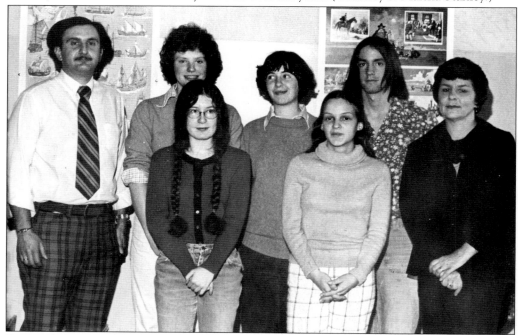

Principal Dr. Stephen Halkiotis and teacher Emma Sue Loftin flank five unidentified students at Orange High School, c. 1980. Halkiotis would later become an Orange County Commissioner. (Courtesy of Marsha Stanley.)

Longtime Hillsboro High School teacher Ellen Craig is shown here in a *c.* 1970 photo. (Courtesy of Marsha Stanley.)

Sisters Elsie Payne and Clovina McPherson are pictured with Elsie's son Frankie in 1949. (Courtesy of Margaret Whitted.)

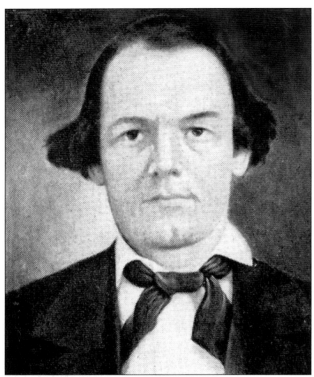

Richard M. Jones served as sheriff in Hillsborough from 1852 to 1862 and again from 1864 to 1865. He owned much of the land on Occoneechee Mountain. (Courtesy of Hillsborough Historical Society.)

This is a backyard family picnic on Union Street, c. 1950. In the foreground are Henry Whitted (left), his mother Irene, and his brother William. In the rear are two unidentified women and Alice Faucette (right). (Courtesy of Margaret Whitted.)

Clovina McPherson and her brother-in-law Ray Delaney are pictured here in 1950. (Courtesy of Margaret Whitted.)

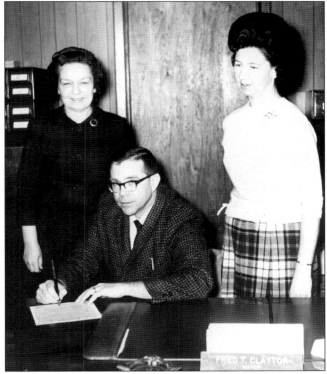

Hillsborough Mayor Fred Claytor is in his office with Dot Gordon (left) and Iris Walker Cates (right). Claytor, who was also the principal at Orange High School, became mayor in 1961. (Courtesy of Marsha Stanley.)

Charles Freeland holds his infant nephew James Rae Freeland in this 1940 photo. (Courtesy of Donna Freeland.)

A meeting of the Hillsborough Garden Club in the 1960s is shown here. From left to right are Mrs. James Wade, Mrs. Robert Isley, Evelyn Patterson, Mary Claire Engstrom, and Dr. Charles Blake. (Courtesy of Marsha Stanley.)

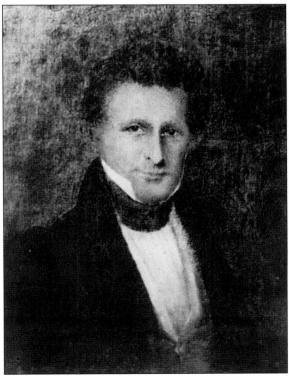

Dr. Edmund Strudwick (1802–1879) was born Orange County and educated at Bingham School. He attended medical school at the University of Pennsylvania and then returned to Hillsborough to set up his practice in 1826. Strudwick became one of North Carolina's most prominent surgeons and his skills were in demand by patients across the state. In 1849 he became the first president of the North Carolina State Medical Society. (Courtesy of Orange County Historical Museum.)

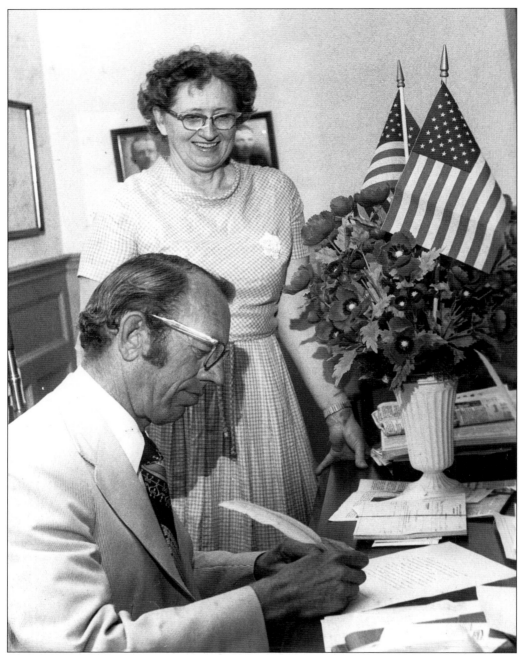

Mayor Fred Cates carries out his official duties while Josephine Barker watches in a mid-1970s photo. (Courtesy of Marsha Stanley.)

Five

SCENES AROUND TOWN

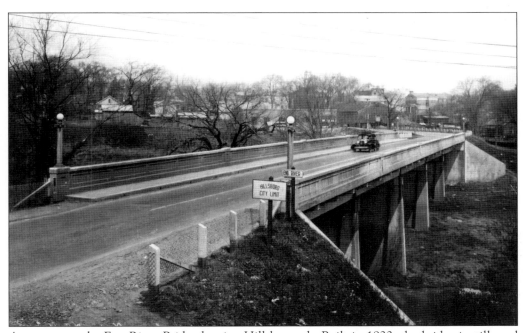

A car crosses the Eno River Bridge leaving Hillsborough. Built in 1922, the bridge is still used today but most traffic uses the newer 1960s bridge just to the east. (Courtesy of North Carolina Collection, University of North Carolina Library at Chapel Hill.)

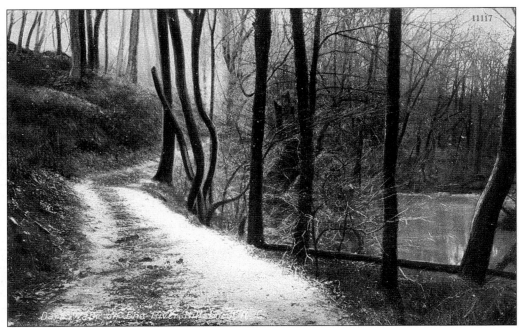

This *c.* 1900 postcard shows the view on Dark Walk along the Eno River, a popular path along the south bank of the Eno River east of Churton Street. (Courtesy of Hillsborough Historical Society.)

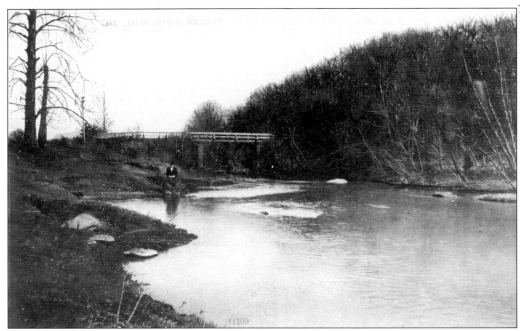

Another early 20th-century postcard, this one shows the "Old Town Bridge" over the Eno River. (Courtesy Hillsborough Historical Society.)

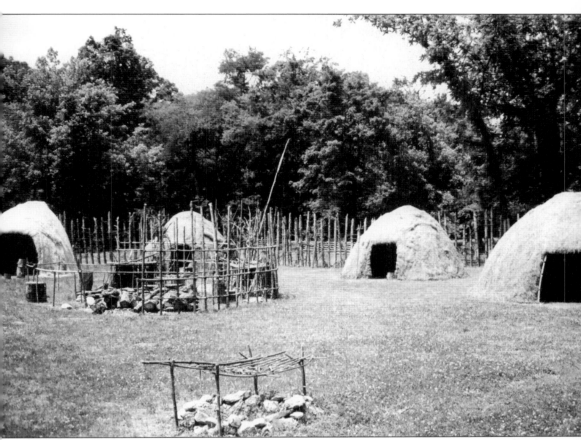

This is probably a very similar view to the one early European explorers would have had when they arrived in what is today Hillsborough. In the late 1990s, the Occaneechi Band of the Saponi Nation began a project to reconstruct a village similar to the type their ancestors would have lived in along the Eno River. The Occaneechi village is surrounded by a palisade wall of pointed poles with saplings woven between them and filled with oval huts. The dwellings, called "atitisel" or "ati," were constructed of layers of river reed mats over a frame of saplings and, in cold weather, layers of tree bark were added to the outside of the huts for insulation. Every June, the tribe now holds a cultural festival and Pow Wow at the downtown site. (Photo by Bitsy McKee.)

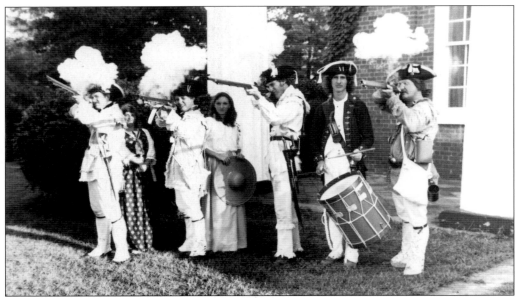

Revolutionary War re-enactors of the 3rd North Carolina Regiment fire their muskets during a 1970s event at the courthouse. From left to right are Bill Adams, Teri Adams, Randy Belvins, Lori Swicegood, Eddie Taylor, Mitch Taylor, and Thom Sevberling. (Courtesy of Hillsborough Historical Society.)

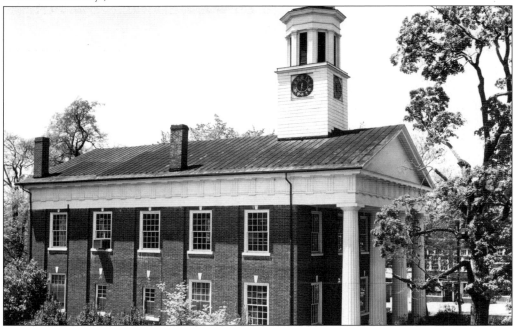

The courthouse clock is one of the most famous in North Carolina. Made in Birmingham, England, it was reportedly a royal gift to the town about 1769 and originally hung in the first St. Matthew's Church of England. It later moved to the tower of the Market House and since late 1846 it has been displayed in the octagonal cupola of the Old Courthouse. (Courtesy of Orange County Historical Museum.)

Cedar Lane was formed in 1817 when Mrs. Frederick Nash planted a row of cedar trees on either side of a broad path from Margaret Lane to West King Street. The trees eventually grew to form an archway over the path. (Courtesy of Hillsborough Historical Society.)

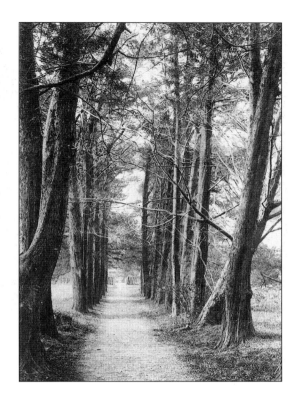

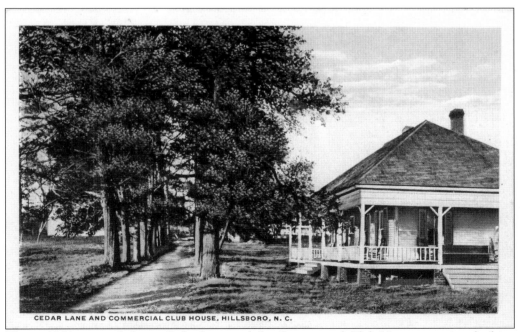

CEDAR LANE AND COMMERCIAL CLUB HOUSE, HILLSBORO, N. C.

This *c.* 1910 postcard shows Cedar Lane and the Commercial Club House in a view looking north from Margaret Lane. (Courtesy of Hillsborough Historical Society.)

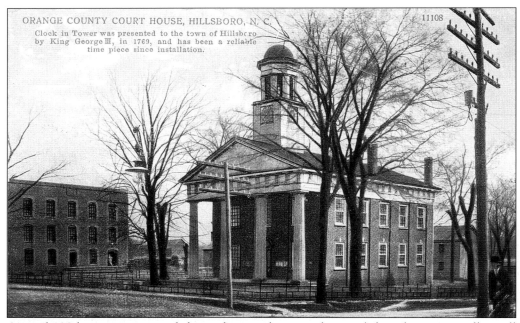

An early 20th-century postcard shows the courthouse and, to its left, a three-story roller mill that produced flour and feed. (Courtesy of Hillsborough Historical Society.)

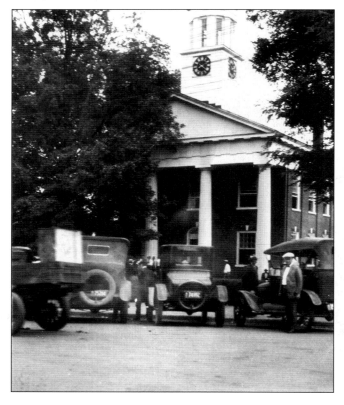

The courthouse has always been at the center of town activities (and traffic) as seen in this *c.* 1920 photo. (Courtesy of Hillsborough Historical Society.)

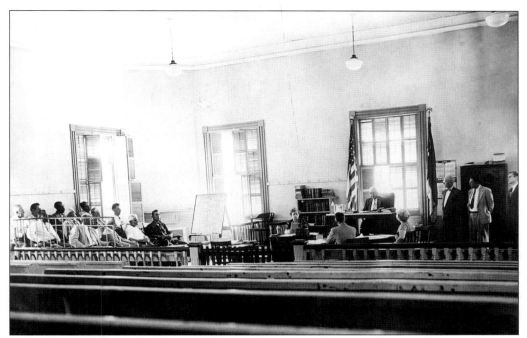

Court is in session in the early 1950s. This photo reportedly shows the last trial to take place in the old courthouse before proceedings were moved to the new courthouse. (Courtesy of Orange County Historical Museum.)

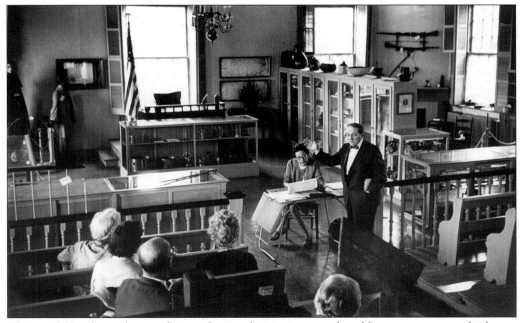

This c. 1960s photo shows a history lecture being given at the old town museum, which was located in the old courthouse. The courtroom is once again used for legal proceedings and the museum moved farther up Churton Street to the building that once housed the library. (Courtesy of Orange County Historical Museum.)

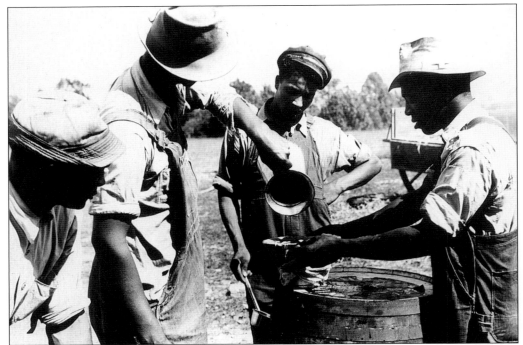

Hillsborough has always been at the center of a large rural area that includes the Orange County communities of Schley, Caldwell, Efland, and Cedar Grove, among others. The photos on this page, taken near Hillsborough in the 1930s, show typical rural scenes of that time. Above, farm workers take a water break while below a farmer operates a sorghum mill. (Photos by Marion Post Wolcott; courtesy of Library of Congress.)

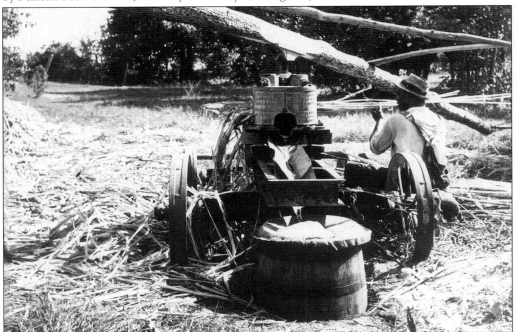

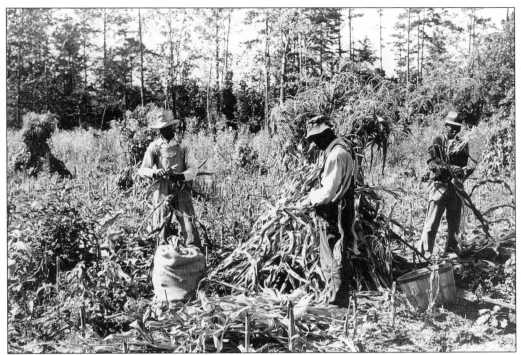

Corn is being harvested in another 1930s Hillsborough-area rural scene. (Photo by Marion Post Wolcott; courtesy of Library of Congress.)

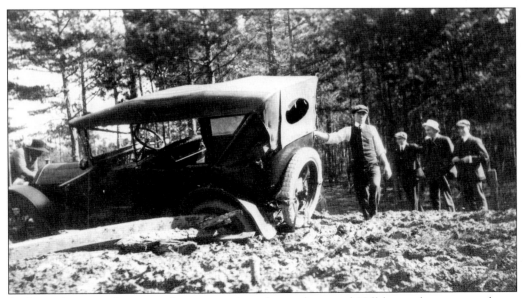

In the early years of motorized transportation, the roads around Hillsborough were not always the best. Here, a car seems hopelessly stuck in the mud in a c. 1920 photo. (Courtesy of North Carolina Collection, University of North Carolina Library at Chapel Hill.)

This was the scene on the front porch of Pender's Grocery in the community of Cedar Grove, a few miles north of Hillsborough, after a baseball game on July 4, 1939. Pictured from left to right are two unidentified, W.P. "Billy" Roberts, Jim Crabtree, David "Bo" Wells, Aubrey Terry, Brodie Crabtree, unidentified, and Gordon "Boss" Anderson. (Photo by Dorothea Lange; courtesy of Library of Congress.)

Churton Street is lined with historical markers. This one honors William Hooper. (Courtesy of Orange County Historical Museum.)

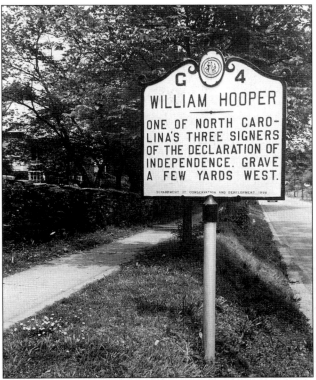

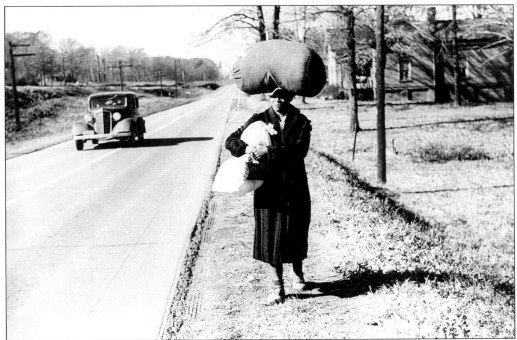

An unidentified woman carries a bundle on her head in a 1930s Hillsborough-area photo. (Photo by Marion Post Wolcott; courtesy of Library of Congress.)

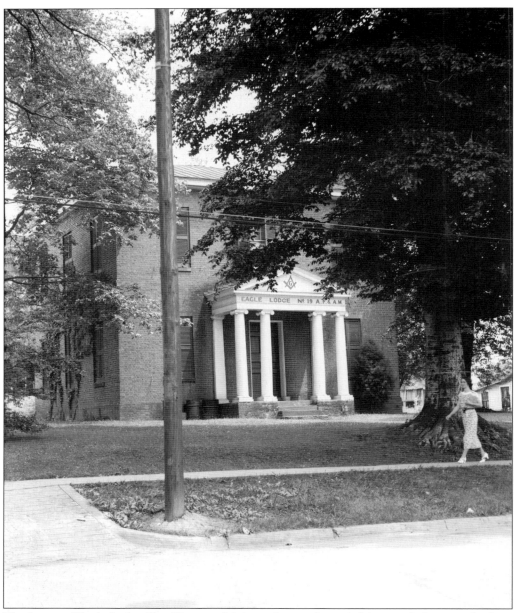

The home of Eagle Lodge No. 19, one of the state's most historic Masonic lodges, was built in 1823 (probably by John Berry). Over the years, the building, which has also been called the King Street Opera House, has hosted all manner of civic activities including lectures and concerts. During the Civil War it was a center for aid. It is seen here in a 1936 photo. (Courtesy Library of Congress.)

The Norwood-Jones Law Office, located just southeast of the courthouse, was constructed in the early years of the 19th century by attorney and superior court judge William Norwood (1766–1842). It was later used by prominent civic leader Cadwallader Jones (1813–1899) and state senator John Wall Norwood (1803–1885). The building, now restored to its original appearance, has also served as the Veterans Service Office. (Photo by Bitsy McKee.)

Confederate Memorial Library, on the corner of Churton and Tryon Streets, was built in 1934 on the site of the Presbyterian Church's Session's House. Today the building houses the Orange County Historical Museum. (Photo by the author.)

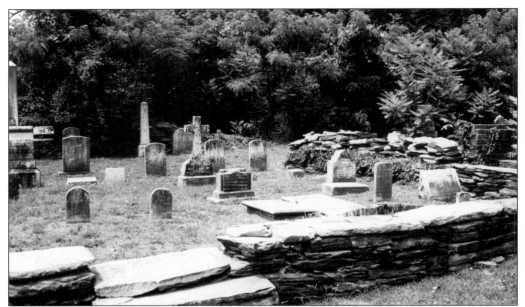

The old town cemetery, located behind the Presbyterian Church on Tryon Street, is the resting place of some of Hillsborough's most famous citizens including William Hooper, Gov. William Graham, builder John Berry, and educator Archibald D. Murphey. Laid out in 1757, the cemetery contains roughly 200 graves. (Photo by Bitsy McKee.)

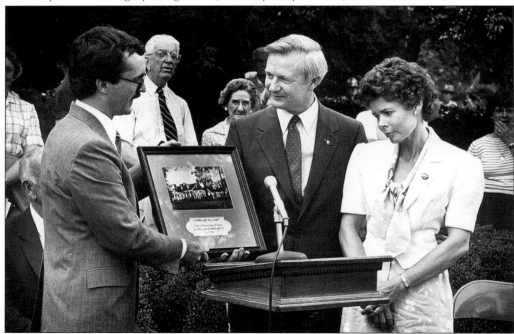

Hillsborough mayor Frank Sheffield presents Gov. Jim Hunt and First Lady Carolyn Hunt with a framed commemorative print at the 1984 rededication of the old town cemetery. The cemetery was restored by a group of local citizens led by Hilda Winecoff, Bill Breeze, and Dr. Roscoe Strickland. (Courtesy of Hillsborough Historical Society.)

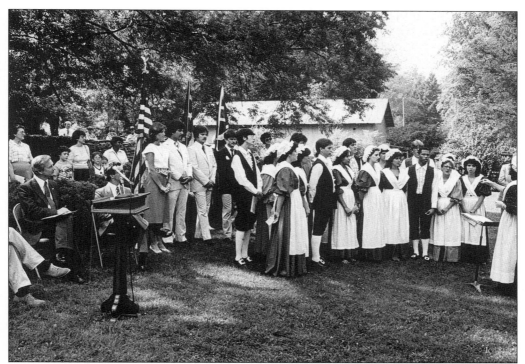

Members of the Orange High School Concert Choir perform in Colonial costume while Gov. Jim Hunt watches at far left. Close to 200 people turned out for the 1984 event at the cemetery. (Courtesy of Hillsborough Historical Society.)

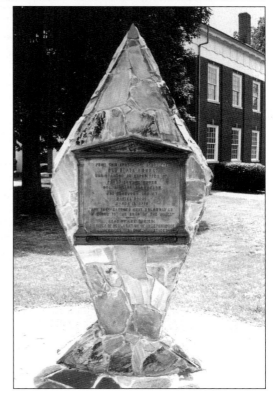

This arrowhead-shaped marker, located at the corner of Churton and King Streets, commemorates an expedition to Kentucky that began at the spot in 1775. For the journey, Col. Richard Henderson hired famous frontiersman Daniel Boone as his guide. The marker is one of many that were erected in the late 1920s by the Boone Memorial Association, a group that sought to bring attention to the accomplishments of Daniel Boone. Interestingly, the plaques on the marker claim to contain metal salvaged from the battleship USS *Maine*, which was blown up in Havana harbor in 1898. (Photo by Bitsy McKee.)

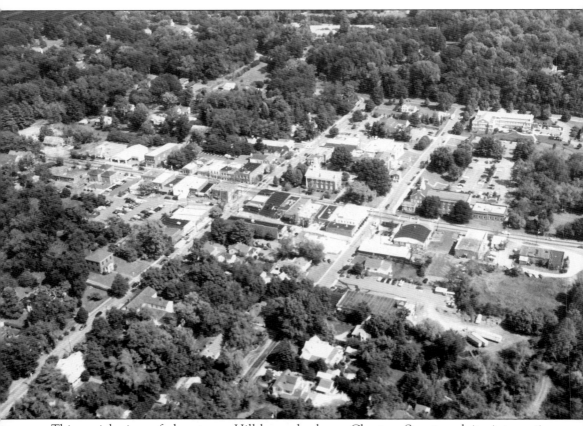

This aerial view of downtown Hillsborough shows Churton Street and its intersections with Margaret Lane (to the right) and King Street (to the left). The street names and the basic layout of downtown have not changed since 1754. (Courtesy of Hillsborough Chamber of Commerce.)

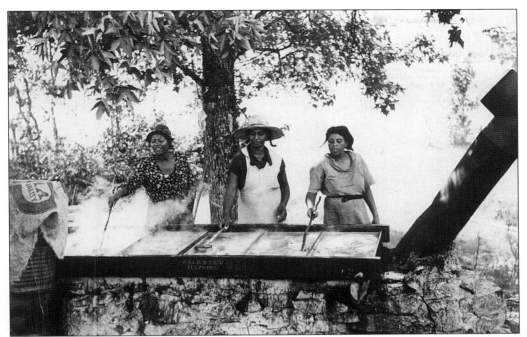

Hillsborough-area women are boiling cane juice to make sorghum syrup in a 1939 photo. Lilian Thompson (center) is flanked by two unidentified women. (Photo by Marion Post Wolcott; courtesy of Library of Congress.)

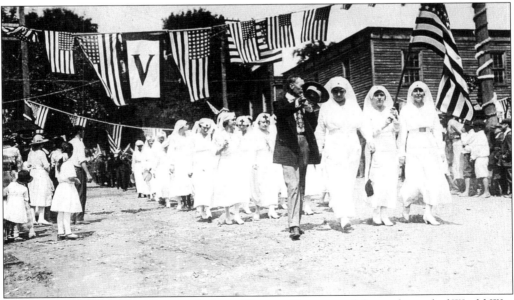

Red Cross nurses march in the parade down Churton Street to celebrate the end of World War I in November of 1918. (Courtesy of Orange County Historical Museum.)

Local residents watch the ceremony at the laying of the cornerstone for the new courthouse in 1953. To help meet the growing needs of Orange County government, the new building was constructed at the corner of Margaret Lane and Churton Street. (Courtesy of Orange County Historical Museum.)

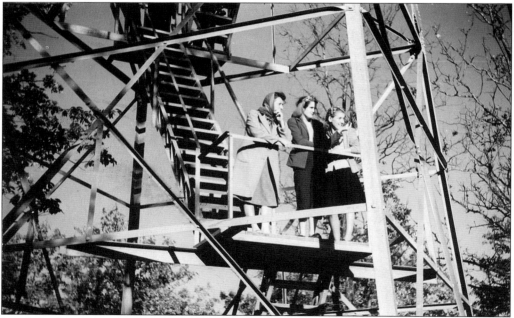

Local residents often visited the fire tower on top of Eno Mountain (also called Occoneechee Mountain) to enjoy the scenic views, particularly during the fall. Here Doris and Kathleen King and Margie Blalock look out over the town in 1945. (Courtesy of Kathleen King Wagner.)

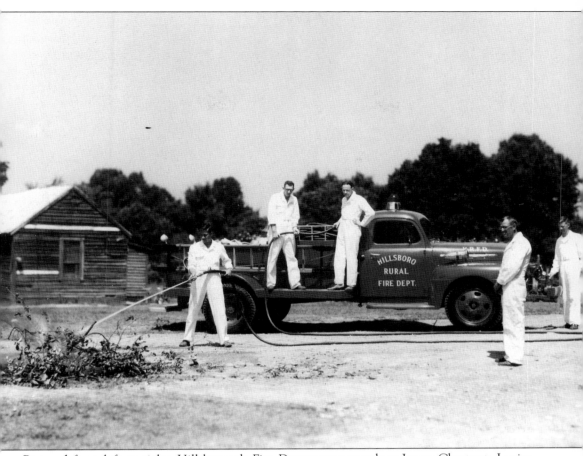

Pictured from left to right, Hillsborough Fire Department members James Chestnut, Lucius Brown, Allen Lloyd, George Gilmore, and Chandler Cates practice putting out a brush fire in the late 1950s. The fire department bought their homemade truck as a bare chassis and added the fire-fighting equipment themselves. (Courtesy of Chandler Cates.)

Julie May Clark Cates is photographed in front of her family's home on Faucette Mill Road, c. 1950. (Courtesy of Margaret Whitted.)

The Ruffin Law Office, located on the grounds of Burnside, was probably built around 1812. It was used by Thomas Ruffin, who went on to serve as Chief Justice of the North Carolina Supreme Court from 1833 to 1852. (Courtesy of Orange County Historical Museum.)

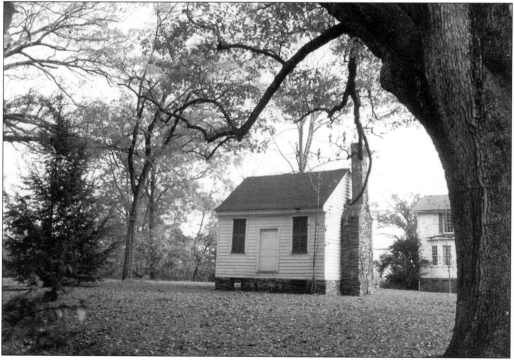

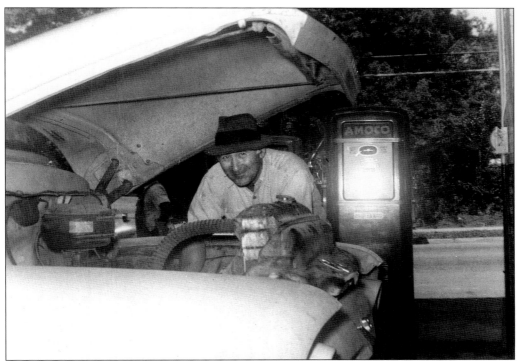

Elbert Horner is checking out a customer's car at the Amoco station on Churton Street in 1961. (Courtesy of Marsha Stanley.)

A scene on Churton Street in 1966. The building, which at the time was occupied by Coleman's Orange Farm Equipment Co., is located on the northeast corner of King Street. (Courtesy of Marsha Stanley.)

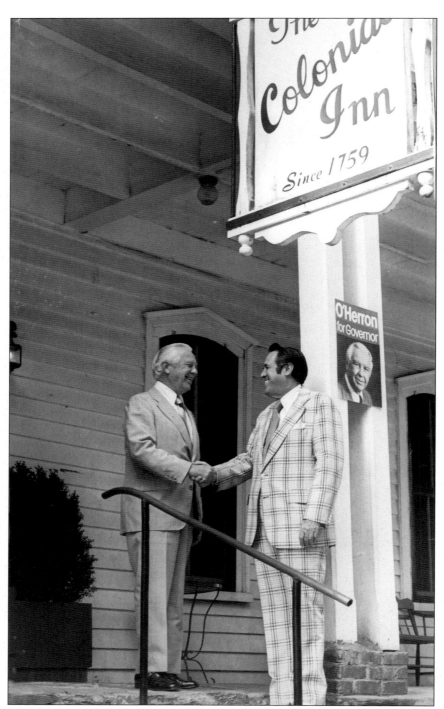

Hillsborough has historically been a center for political activity. Here Colonial Inn owner Pete Thompson greets gubernatorial candidate Ed O'Herron at a 1976 rally. O'Herron, from Charlotte and a founder of the Eckerd's drugstore chain, eventually failed in his bid to become North Carolina governor. (Courtesy of Marsha Stanley.)

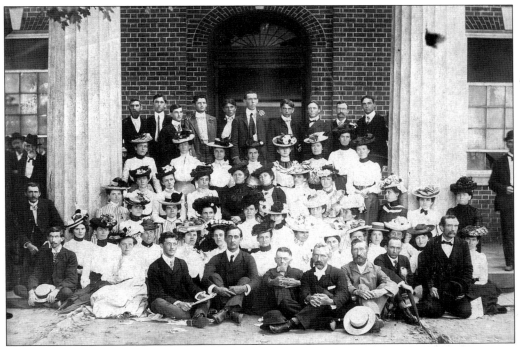

An unidentified group of Hillsborough residents gather for a photo in front of the courthouse, c. 1890s. (Courtesy of Orange County Historical Museum.)

This office on the grounds of Sans Souci on East Corbin Street was constructed in the early 1800s for the medical practice of Dr. William Cain and was later used in the same capacity by his son-in-law Dr. Pride Jones. (Courtesy Library of Congress.)

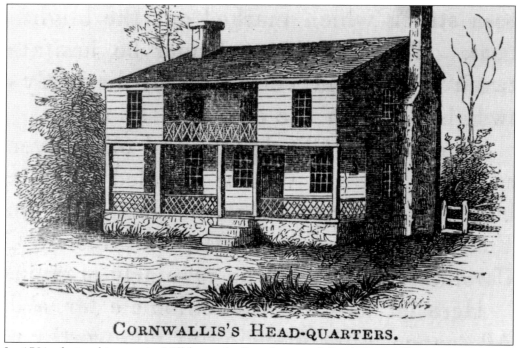

CORNWALLIS'S HEAD-QUARTERS.

In 1781, during his stay in Hillsborough, British general Lord Cornwallis reportedly made his headquarters at Faddis' Tavern. The tavern, shown here in an 1849 sketch, was probably built in 1767 and can be seen on Sauthier's 1768 map of the town. Located on an alley on the north side of East King Street, the building apparently faced Churton Street. The last remnants of this Hillsborough fixture were torn down around 1900. (Courtesy of Hillsborough Historical Society.)

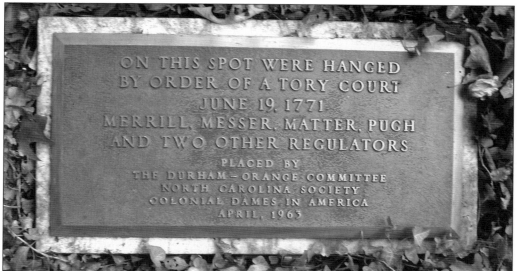

Here is the plaque marking the site east of downtown where six Regulators were hanged in 1771. The memorial, dedicated in 1963, is located behind the Orange County Board of Education building on Cameron Street. (Photo by the author.)

Robert Wilson, Ida Cearnal, and Wilbur Faucette are shown outside the Hillsboro Colored School, c. 1945. In the background, to the left, are Annie Ross and Margaret McBroom. (Courtesy of Margaret Whitted.)

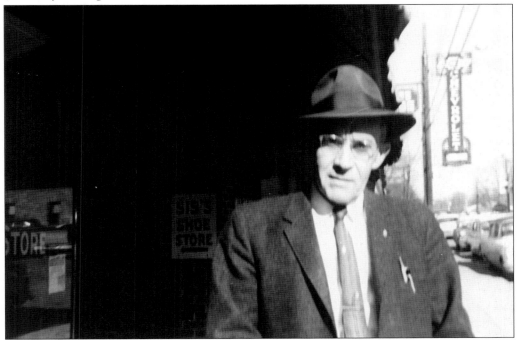

Carl Davis, who was the Orange County Tax Collector and later manager of the county's ABC stores, is shown outside of Sis's Shoe Store on Churton Street, c. 1960. (Courtesy of Marsha Stanley.)

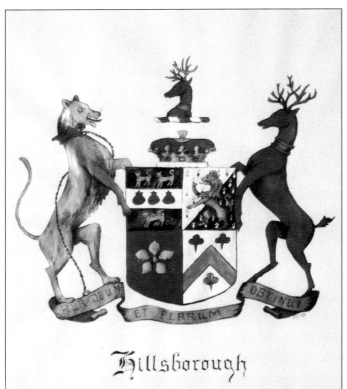

This is the official crest of the town of Hillsborough as displayed at the Orange County Historical Museum. (Courtesy of Hillsborough Chamber of Commerce.)

The east end of the Nash Law Office (left) was possibly built by Gen. Francis Nash in the early 1770s. Duncan Cameron's law practice used the building from 1801 until Chief Justice Frederick Nash took over in 1807. He then occupied the office for the next 51 years. The two rooms on the west end were constructed in the early 1860s when the building became part of the Nash-Kollock School for girls. (Courtesy Library of Congress.)

The "Big Barn" at the Daniel Boone complex has been an important feature in Hillsborough since the 1960s. Over the years it has been used for countless conventions, parties, wedding receptions, and other events. (Courtesy of Hillsborough Chamber of Commerce.)

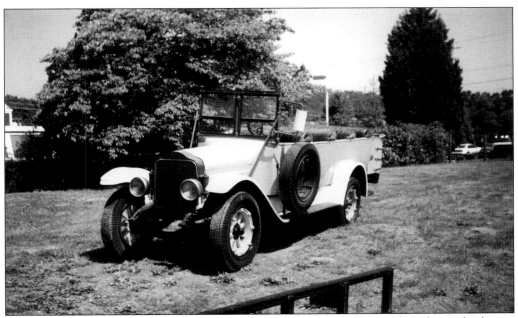

This is one of the many antique cars collected by James Freeland and on display at Daniel Boone Village. This vehicle is a 1925 White, which was once used to carry tourists at Yellowstone Park and later had a cameo role in the movie *The Color Purple*. (Courtesy of Donna Freeland.)

Young Arlene King stands on the Eno River dam near the mill in 1950. (Courtesy of Kathleen King Wagner.)

Six
Sports,
Entertainment, and
Events

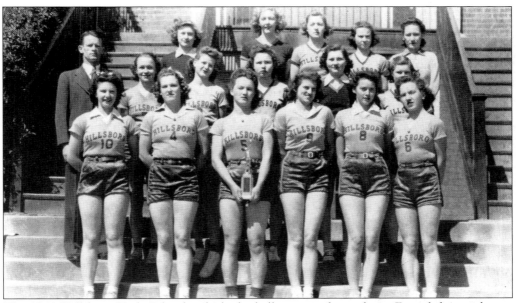

The 1941 Hillsboro High School girls' basketball team is shown here. From left to right are (front row) Madges Hayes, Edna Reitzel, Doris Howerton, Janet Scott, Elizabeth Miller, and Carol Howerton; (middle row) Coach Glen Auman, Gertrude Bivins, Violet Chance, Grace Mitchell, Dallie Marie Liner, and Isabelle Webb; (back row) Peggy Cates, Betty Johnson, Ruby Laws, Josie Crews, and Assistant Coach Margaret Dixon. (Courtesy of Chandler Cates.)

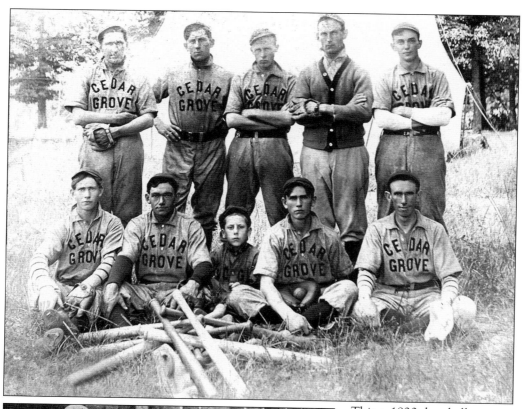

This c. 1920s baseball team represented the Hillsborough-vicinity community of Cedar Grove. (Courtesy of Orange County Historical Museum.)

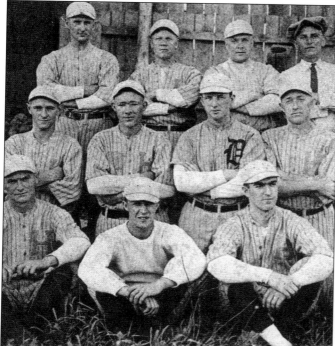

As in most small towns in the years before World War II, baseball was a very popular form of entertainment in Hillsborough. This team represented the town in area play in the 1920s. From left to right are (front row) Frank Cole, Buck Hughes, and Bill Toler; (middle row) Harvey King, Coots Dorrity, Sam Hughes, and ? Mallory; (back row) Bill Dixon, unidentified, Bill Alexander, and Shirley Hicks. (Courtesy of Kathleen King Wagner.)

William "Bootsie" Whitted was a pitcher for the Hillsboro All-Stars, a baseball team that played home games at McPherson Park on Nash Street. (Courtesy of Margaret Whitted.)

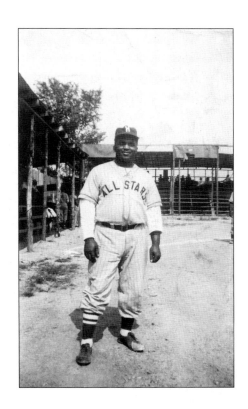

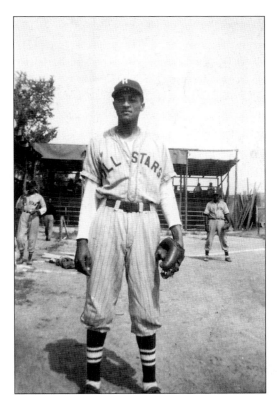

Marvin McPherson was also a member of the Hillsboro All-Stars, the popular area baseball team of the 1940s and 1950s. (Courtesy of Margaret Whitted.)

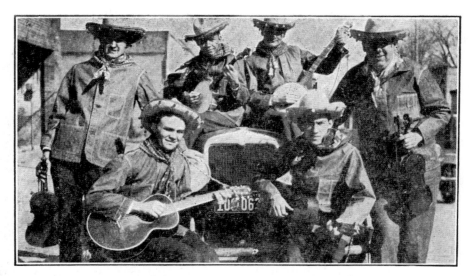

"THE BARN DANCE GROUP OF THE HILLSBORO SERENADERS"

The Hillsboro Serenaders were popular entertainers at area dances during the 1920s. From left to right, members are (front row) unidentified and Bob Tyson; (back row) Charlie McBroom, unidentified, Haywood King, and unidentified. (Courtesy of Kathleen King Wagner.)

In the early 1950s, Kathleen King, Dorothy Lane, and Estelle King formed a singing group known as the King Sisters. They performed at events around the area. (Courtesy of Kathleen King Wagner.)

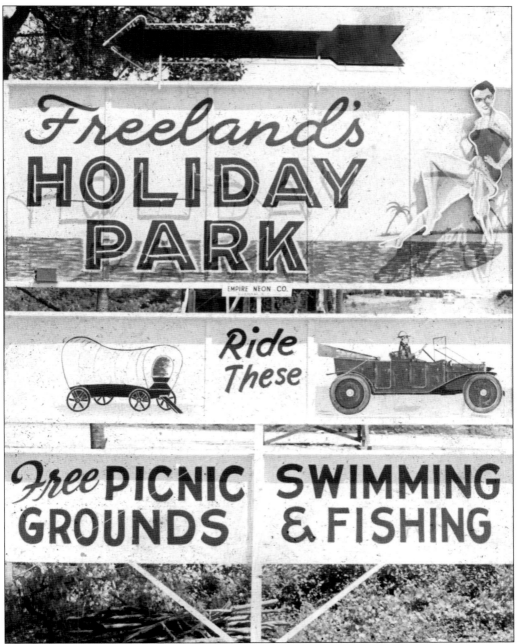

A popular attraction in the 1950s and early 1960s, Freeland's Holiday Park, located on Highway 70 West, featured a swimming pool among other various attractions. James Freeland eventually moved his entertainment operation to the south side of town where he established Daniel Boone Village next to I-85. (Courtesy of Donna Freeland.)

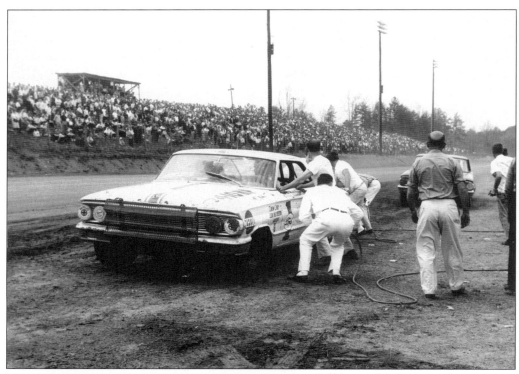

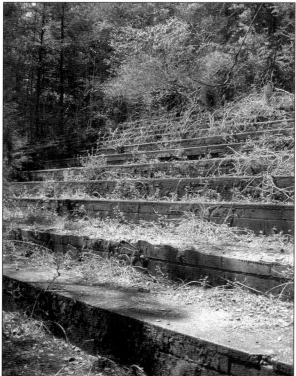

Hillsborough's Occoneechee Speedway (later called Orange Speedway) was one of the original circuit tracks during NASCAR's first season in 1948. Here, the pit crew of #1 Dick Hutcherson jumps into action during the race at the track on April 12, 1964. As they were for most races at the speedway, the stands were packed with fans. (Courtesy Classic American Homes Preservation Trust [CAHPT].)

The concrete grandstand at Occoneechee Speedway is shown as it appears today. Richard Petty won the last race at the mile-long dirt track on September 15, 1968. The following season, Occoneechee's race dates were given to the new speedway at Talladega, Alabama, bringing to an end Hillsborough's involvement with NASCAR. (Photo by the author.)

Not much remains of Occoneechee Speedway today, as apparent by this view down what was once the straightaway. A light tower can still be seen rising above the trees. The site has recently been placed on the National Register of Historic places, a move intended to protect if from development. (Photo by the author.)

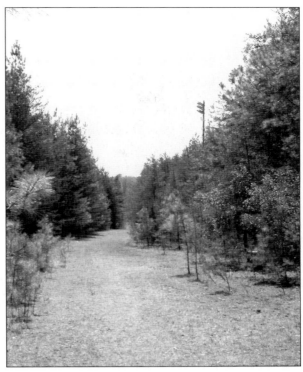

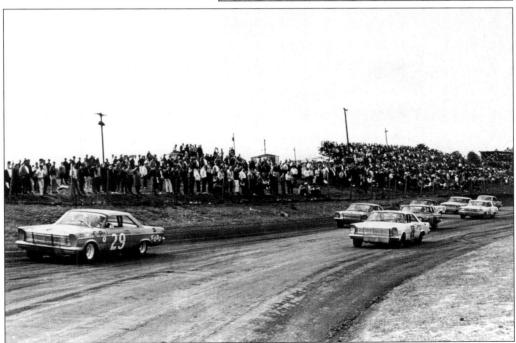

In this photo #29 Dick Hutcherson leads #26 Junior Johnson and the rest of the pack as he approaches the turn in a race on March 14, 1965. Ned Jarrett was the race's eventual winner. (Courtesy CAHPT.)

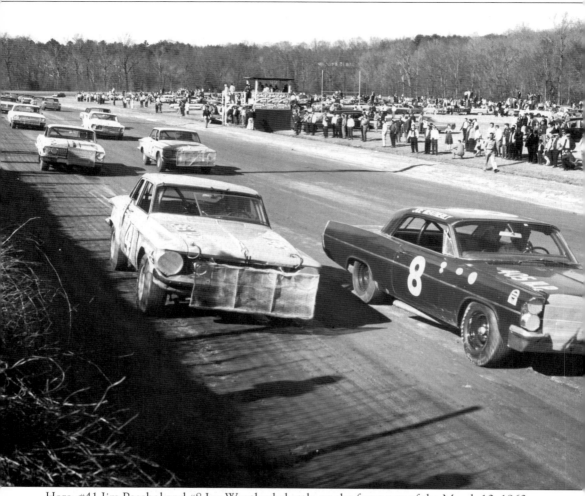

Here, #41 Jim Paschal and #8 Joe Weatherly battle on the front row of the March 10, 1963 race; #43 Richard Petty is on the inside of the second row. Races at Occoneechee were probably not the safest events, considering there was no protective barrier between the track and the spectators. The infield of the track was used for a time as the football field for Orange High School and a goalpost is visible in this photo. (Courtesy CAHPT.)

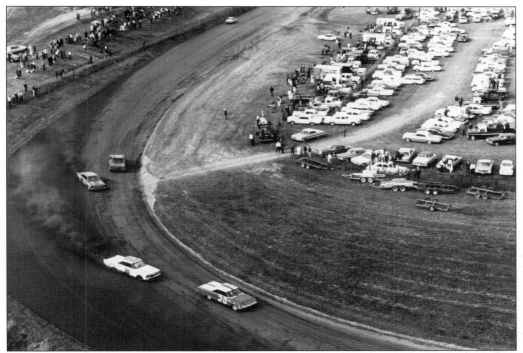

Pictured on October 24, 1965, #6 David Pearson leads the race at Occoneechee, followed by #20 Clyde Lynn, #26 Junior Johnson, #11 Ned Jarrett, and #38 Wayne Smith. Dick Hutcherson would take the checkered flag in the race. (Courtesy CAHPT.)

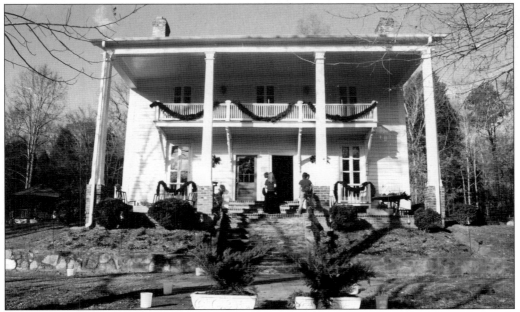

The Candlelight Tour of historic homes, held in December, gives visitors a chance to see inside some of Hillsborough's historic homes and other buildings. Here guests pay a call on Poplar Hill. (Courtesy of Hillsborough Chamber of Commerce.)

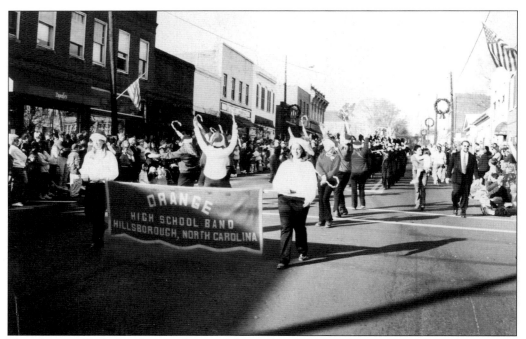

The Orange High band, seen here in the early 1990s, is always featured in the popular Hillsborough Christmas Parade. (Courtesy of Hillsborough Chamber of Commerce.)

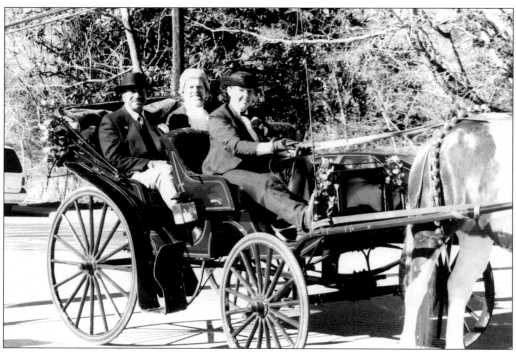

Mayor Horace Johnson (left) rides in the Christmas parade in the early 1990s. (Courtesy of Hillsborough Chamber of Commerce.)

An unidentified team of contestants in the Hog Day barbecue cook-off pose in front of their cooker in this early 1990s photo. Close to 10,000 pounds of barbecue is cooked at the festival and then sold in sandwiches and one-pound containers. (Courtesy of Hillsborough Chamber of Commerce.)

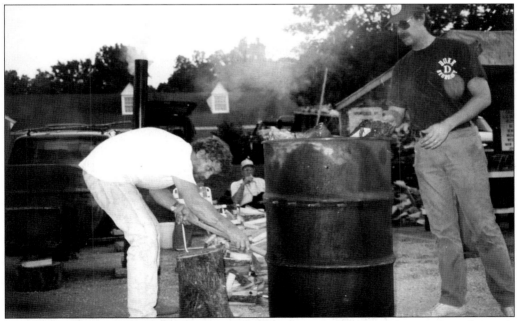

Another unidentified team of barbecue cook-off contestants burns wood to produce the coals that will cook their pork. The quality—and quantity—of the barbecue at Hog Day is famous around the region. In 2000, the event made the Guinness Book of World Records as the world's largest one-day barbecue festival with 48,000 people in attendance. (Courtesy of Hillsborough Chamber of Commerce.)

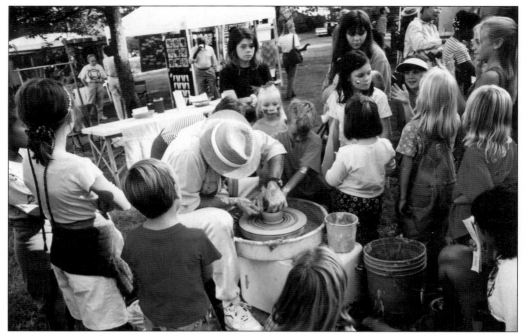

Every June, Hillsborough's hugely popular Hog Day brings thousands of visitors from across the region to the town. Since the early 1980s, the event has featured arts and crafts, the area's largest antique car show, a petting zoo, well-known musical acts, and, of course, barbecue. Here, at an early 1990s Hog Day, an unidentified potter teaches a group of children some of the finer points of his art. (Courtesy of Hillsborough Chamber of Commerce.)

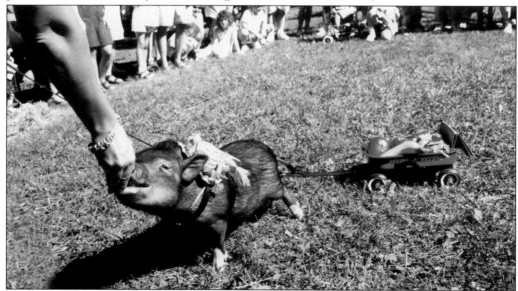

Among the various contests (hog hollering, Spam carving, etc.) that take place at Hog Day, perhaps the most entertaining is the one for the best-dressed pot bellied pig. This contestant, complete with vegetable-adorned straw hat and trailer, parades before the crowd in an attempt to capture the coveted prize. (Courtesy of Hillsborough Chamber of Commerce.)